Glasgow

Phaidon Architecture Guide

Glasgow

Frank Arneil Walker

Phaidon Press Limited
140 Kensington Church Street
London W8 4BN

First published 1992

© 1992, Frank Arneil Walker

ISBN 1 85454 301 6

A CIP catalogue record for this book is available from
the British Library

Printed and bound in Hong Kong

Contents

This imperfect guide is dedicated to Frederick Selby,
my teacher and friend.

Preface

Glasgow is more a city of streets than of buildings. Its urban presence is compelling. Yet this has little to do with the grand planning of boulevard and civic space or with overt scenic contrivance. What makes the place memorable is a simpler, at times implacable, integration manifested in the grid and the tenement. Four-square and four-storeyed, Glasgow's plan and Glasgow's elevation do not always coincide in the particular – in the gridded inner city the scale rises, in the tenemented suburbs grids clash and break down – but they dominate the broader perception of the city. Glasgow is a coherent but never dully consistent domain.

This quality makes it difficult, even dangerous, to detach architecture from the matrix. Urban context may be lost. Moreover, problems of strictly architectural selection and judgement compound the dilemma of how to put together a guide such as this. Choice should, of course, be representative of historical period, building type, locality, individual designers, etc. – but scarcity and idiosyncrasy also have a claim. In any event, opinions will differ.

In this guide, the reader will find Glasgow's buildings grouped geographically. Five areas have been determined: the Medieval and Merchant City, the Victorian City, the West End, the East and North, and South of the River. To some extent, though not entirely, this sequence also makes historical sense, following the city's development from medieval cathedral town to the New Town expansion promoted by a mercantile aristocracy in the late 18th century to the industrial, commercial and residential growth that accompanied Glasgow's rise to become Second City of the Empire.

Within the five principal areas are several sub-groups in each of which the more interesting buildings of a particular locality have been identified. Most of these local groupings can be regarded as city walks and the enthusiast with stamina may easily move from one local walk to another either on foot or using the city's buses and underground. It has not, of course, always been possible to achieve such proximate convenience: in the outer suburbs where selection is more diffuse and distances inevitably greater, it will certainly be best to get around by car or taxi.

While an attempt has been made to be comprehensive, to offer a wide range of building types and to show the work of Glasgow's finest architects past and present, an architectural guide such as this, based predominantly on a compilation of individual buildings, must run a risk of misrepresentation. For

the sake of the trees, the wood may be lost. Many splendid single trees have been identified here; nonetheless, their frequency and density – certainly in the streets of the Inner City – will ensure some apprehension of Glasgow's gridded richness while, beyond the centre of town, the selection of whole areas such as Park, Woodside and Hyndland will perhaps provide the chance to experience those terraced and tenemented suburbs which are so ubiquitously a part of Glasgow's townscape.

I have said that Glasgow is more a city of streets than of buildings. But this, like the idea that one can somehow capture the urban genius loci without being 'in the midst', is too simple. The city is always about both streets and buildings. Indeed, it is not only about architecture and urban plan but about their united interplay with the physical landscape beyond, above and underfoot: the city, in short, is an alternating patchwork of figure and ground. I must hope that the selection which follows may maintain something of the contextual pleasure of that very ambiguity.

Introduction

For most visitors to Glasgow it is the road from the south that brings a first sight of the city. Motorway miles of nondescript suburban housing schemes; high-rise from the 1960s, gaudily cosmeticized by 1980s rehab; nothing that is architecturally remarkable – except, perhaps, two giant gasometers in saxe blue livery rearing up on the right. Most will miss the city's medieval cathedral, dark and diminutive on the left. But then, as the road dips and chicanes unexpectedly, the silhouette of Woodlands Hill stretches across the western sky – terraces, towers and spires and, beyond, the fretted outline of Gilbert Scott's Victorian Gothic University on Gilmorehill. The view is expansive, majestic even, but momentary; in seconds, a slip road swings off through Charing Cross to penetrate the denser gridded space that lies at the heart of the inner city.

The air traveller, landing south of the River Clyde, is less than half-an-hour's drive west of the centre of town. This approach is fast and not without clues to the city's past. Cranes still line the river's edge to the left; factories and ageing warehouses crowd along the motorway flanks. Turning north across the Clyde, a five-lane incline breasts Kingston Bridge. Glasgow is revealed, unexceptional at first but, thrown across the ring road cut on an elevated loop that plunges through the Modernist marches of the inner city and on into Bothwell Street, there is a sudden sense of arrival as squared-up cliffs of Victorian and Edwardian buildings close in with their unique urban intimacy.

For those who come by rail this discovery of the inner city is memorably abrupt and astonishing. Passing beneath the great glazed roofs of Central Station out from the inner space of the concourse into the tall tight confines of Gordon Street, Union Street or Hope Street is to grasp Glasgow with an unforgettable immediacy. This is the essential city. No 'dear green place', as the Gaelic origins of its name are said to invoke, but a hard, stone place, wholly urban, the deep defiles of its quadratic plan rich in texture and decorative delight; an 18th century grid drenched in 19th century dress.

The urban form of the inner city – that area north of the Clyde lying west of the ancient line of High Street and held within the sweep of the motorway ring – is simple, a matrix of east–west, north–south streets. The grid is relentless. Indifferent to topography it began on flat ground immediately west of the medieval Cross when, in the 1770s, the success of 18th century transatlantic trade in tobacco and sugar had produced a mercantile aristocracy intent on the physical enhancement and expansion of their burgeoning city. Then it spread west with uninterrupted

business-like logic across the drumlin ridges of the Blythswood estate lands as the century ended and a new prosperity, based first on the textile trade but later on heavy industry stimulated by coal and iron, ensured continuing growth. Naïvely, not to say stubbornly, straightforward in its geometry, the city centre plan was thus consistently acquisitive but – and this is perhaps significant in distinguishing the Glaswegian spirit from, say, that of its national rival, Edinburgh – democratically so. For just as the street pattern is largely without hierarchical inflection, so too there is little sense of socio-spatial layering in the inner city.

There is, notably, no centre to the place. The nearest approximation might be the Z-plan line of Trongate-Argyle Street/Buchanan Street/Sauchiehall Street, which threads its way through the grid from Glasgow Cross in the east to Charing Cross in the west. But this is a commercial path, linear rather than nodal. Others might say George Square, the principal open space in the city centre grid and forecourt to the lavish vaguely Venetian facade of the City Chambers. But this, too, is somehow off-centre and only intermittently a focus for civic expression. Claims for Cathedral Square are even less sustainable for, despite recent developments which have given a new architectural definition to this sacred spot, it clings only precariously to the north-eastern edge of the inner city, regrettably remote from real urban life.

Yet it is here at the Cathedral that Glasgow's origins lie. From its beginnings as a religious settlement clustered around a 13th century cathedral, Bishop's Castle and the so-called 'Quadrivium' crossroads gathered on the hillside above the western bank of the Molendinar Burn, the medieval town spread south downhill to the ford across the River Clyde. Besides the Cathedral itself, only a single house, Provand's Lordship, remains to recall this early Glasgow, though the curving climbing line of High Street is still more or less that of ancient times. The move south, stimulated in part by the building of the first stone bridge across the River Clyde, (c.1350), by the foundation of the University in 1451, but most of all by the impact of the Reformation, which undermined both the spiritual and temporal power of the clergy in the upper town, created a new mercantile focus at Glasgow Cross. Some skyline pointers to the modest but, by Scottish standards, significant status of the 17th century town still stand – the Tolbooth tower (c.1626), the Tron Steeple (1592–1636) and the Merchants' Steeple (1665). But today, there is no medieval Glasgow.

Of Georgian Glasgow much survives; much, that is, in terms of urban structure for, from the 1720s when King Street and Can-

dleriggs were deliberately aligned at right angles to Trongate, and, more comprehensively, from the 1770s when this same geometry was incorporated into proposals drawn up by the city surveyor James Barry for a first New Town around George Square, the plan of the inner city has maintained its strongly gridded form. There are inner subtleties – in the 1790s New Town, now known as the Merchant City, there is much closing of the grid with important point-de-vue buildings, whereas in the later Second New Town, built up across Blythswood Hill and Garnet Hill between 1800 and 1840, the streets of the grid present an always open prospect – but the idea of regularly plotted street blocks is consistent.

Some of these city blocks retain their original residential buildings – one or two in the Merchant City, rather more on the upper slopes of Blythswood – though few are still in residential use. Most, however, have been redeveloped so that not only has the original two- or three-storey scale been replaced by higher second or third generation building but the architectural character of downtown Glasgow has been transformed by an opulent historicism of Victorian and Edwardian times into which an admixture of shiny reflective Modernism has been introduced and a few more recent promising examples of Po-Mo contextualism.

Architecturally, Glasgow is a predominantly classical city. Georgian elegance and restraint linger in some 18th century survivors and, of course, in the few buildings of Robert Adam and David Hamilton. But it is the mid-century work of Charles Wilson and that creative Grecian inventiveness passed through John Stephen to Alexander Thomson which achieve most. Mansions, churches, offices and warehouses are all explored in a common trabeated language. James Smith, John Rochead, James Sellars, John Burnet, J.J. Burnet, John Honeyman, John Campbell, James Miller all participate. But by far the most coherent and compelling presence of classicism is to be found in the terraces of the Blythswood New Town and, most ubiquitously, in the ashlar tenements that still line so many of Glasgow's streets.

These tenements, generally four-storeyed walls of superimposed flats grouped in twos, threes or fours around each level of a common access stair or 'close', are present in virtually every Scottish city and town – sometimes even villages. Not only do they spring from a national tradition of high urban living that goes back to medieval times, but they provide – and nowhere more so than in Glasgow – a backdrop that unifies townscape in a quite exceptional and powerfully architectural way. Despite the ravages of

comprehensive redevelopment in the 1960s, they still remain in abundance not so much in the inner city area as in the inner suburbs beyond the motorway ring, particularly to the west and south in those once independent burghs like Hillhead, Partick, Maryhill, Govan, Shawlands, Pollokshaws and Govanhill, absorbed by the city's municipal expansion between 1890 and the First World War. As a building type, the tenement could respond both to working class and middle class needs, while its architectural expression could vary from the severe almost astylar facade to the most eclectic and inventive composition. Unjustly discredited through overcrowding and lack of maintenance, the tenement fell from favour as an urban model in the 1920s. It made an ineffectual return in the 1930s and a more forceful but ignored one at Woodside at the start of the 1970s. Now, at Shakespeare Street (1987–88) the paradigm has once more revived, but with what wider potential for renewal, rather more genuinely urban in material and scale than the pusillanimous brick housing now increasingly infesting the city, remains to be seen.

Renewal is, in fact, the name of the urban game in Glasgow today. From the early 1970s when the first Conservation Areas were designated and tenement rehabilitation was shown to be both feasible and desirable, the city has been recovering its self-respect and self-confidence. With decades of pollution washed off its stone facades, it smiles better. A strangely reciprocal metamorphosis has emerged. In the inner city, Victorian elevations stand preserved like stiff street curtains as interiors are gutted and transformed – warehouses into flats, dark offices into light-filled atria, shallow terraces into deep-plan bürolandschaft – while in those desperately isolated and disadvantaged housing schemes on the periphery, interiors remain but facades and gardens pull on the latest Po-Mo fashion. Not every prospect pleases, of course, but the balance is undoubtedly healthy. There is, moreover, new-build – and not just the sleek imported facades of a glossy commercial infill that could be anywhere, but, especially on the streets of a reinhabited and revitalized Merchant City, a new 'Glasgow-Style' idiom carefully crafted by the city's own younger architectural practices. These designers know and love their city enough to ensure that, though the opportunities afforded their Victorian predecessors are unlikely to return, the more modest legacy of this new fin de siècle may be as vigorously urban.

Acknowledgements

Although choice is a personal matter, the compilation of an architectural anthology such as this guide may be deemed to be, cannot be done without help. I am above all grateful, therefore, to the many architectural practices, surveyors and developers who generously responded to my approaches. Their ready co-operation, providing plans and photographs, I greatly appreciate. It has, however, been necessary to exclude much material – a matter of some regret to me but I hope not too great a disappointment to them. Lack of space also prevents my listing all such sources. I must however, record some special thanks to the following:

AHAUS (Archive of Historical Architecture University of Strathclyde), The Archive of Historical and Business Records Centre University of Glasgow, Department of Architecture and Related Services Glasgow District Council, Mitchell Library Glasgow District Council, National Monuments Record at the Royal Commission on the Ancient and Historical Monuments of Scotland, National Trust for Scotland, Royal Incorporation of Architects in Scotland and Strathclyde Regional Archives.

Thanks are due also to Charles Brown, James Cooke, Anne Dick, Patricia Douglas (who was kind enough to suggest I might write this guide), Gerry Grams, Angus Kerr, Lesley Kerr, Marion Leitch, Keith Miller, Gordon Murray, Peter Robinson and Ian Will. I am grateful to Philippa Clements and Tom Neville for their friendly help and patience. To Ellen Thomson, Kay O'Farrell and Alice Doyle, special thanks are due for typing and retyping my text.

None of the above shares any responsibility for views expressed in this guide. As with any errors or omissions, these views are my own.

Frank Arneil Walker
Kilmacolm

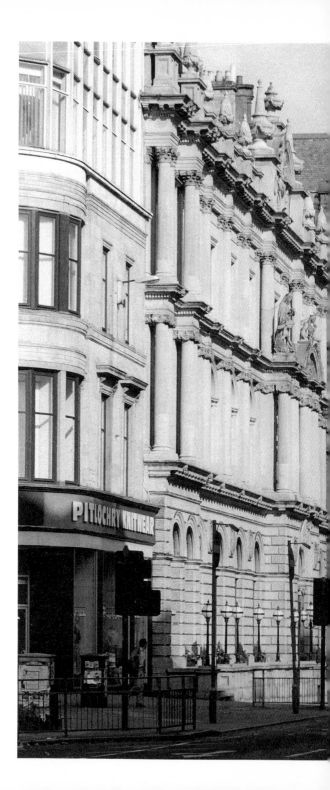

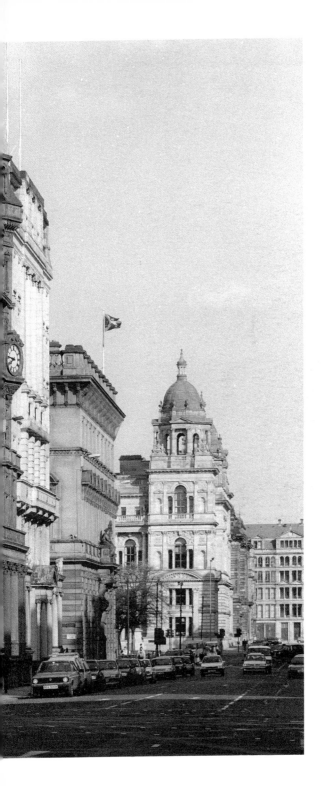

The Medieval and Merchant City

Townhead

1 **Glasgow Cathedral**
Cathedral Square
from 13th century
Architect: unknown

Diminished by the amazingly graceless bulk of James Miller's Royal Infirmary (1904–14), the western gable of Scotland's finest surviving medieval cathedral is at first something of a disappointment. Not even Page and Park's new paved forecourt (1988–90) manages to raise expectations much beyond the dutifully respectful. This is no Lincoln or Durham.

Yet seen from the east – the view chosen by nearly every topographer from the Middle Ages to Mackintosh – buttresses and lancets build together out of the tumbling landscape of the Molendinar valley to create a dramatic Gothic hillside. Set on this sloping site, the section steps up at the crossing through a 15th century stone rood screen into the choir and down to a Lower Church where St Mungo's shrine shelters in the dark amidst thick trunk piers and branching vaults.

A split-level cathedral – cramped in width perhaps but for that very reason all the more inspirational, it is at its most intriguing in this middle zone of sudden spatial surprise. From here, for example, steps plunge down to the right into the white-ribbed cave of Blacader Aisle (15th–16th century) painted to evoke Le Corbusier's dream of a time quand les Cathédrales étaient blanches.

Nowhere is size the touchstone. It is all a question of intimate enclosure and a dignified dour aesthetic drawn from the stern coherence of the 13th century.

2 **The Necropolis**
Cathedral Square
from 1833
Architects: John Bryce et al.

Across the Molendinar valley from the Cathedral, on a green hill far away from the city's downtown bustle but close to its roots, the contoured paths and green banks of a new municipal graveyard were laid out following the model of the Père Lachaise cemetery in Paris. Thomas Hamilton's John Knox Monument (1825), Doric and appropriately admonitory, already dominated the hilltop and the city's saints soon followed. In less than a generation the Necropolis had become a convenient introductory

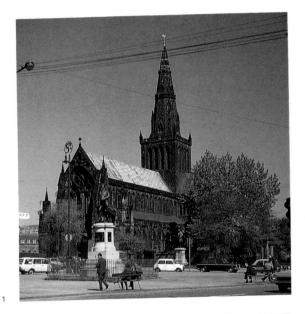

1

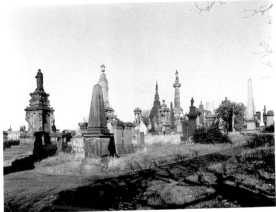

2

guide to Glasgow's architects and architecture. John Baird, John Bryce, David Hamilton, J.T. Rochead, John Stephen, Alexander Thomson and Charles Wilson are all represented. As for styles – Egyptian, Greek, Roman, Romanesque, Gothic, Moorish, Italianate – everything is in evidence.

3 **Cathedral Visitors' Centre**
Castle Street/Cathedral Square
1988–90
Architect: Ian Begg

Designed to provide a much-needed interpretation centre where visitors can learn about the history of the city and its cathedral, this five-storey towered, chimneyed and gabled stone building is, in Begg's customary way, provocatively traditional. Forms are unashamedly Scots, from the L-plan arrangements marking the corner with John Knox Street where the foundations of the medieval Bishop's Castle were revealed before construction began, to the corbelled gable and cone-capped turnpike stair across the street from Provand's Lordship (q.v.). Trace elements of Gothic are here, too: large pointed arch windows provide light to the main hall on the first floor; arcading defines the cloister garth held in the internal angle of the plan. Such consciously nationalistic collage has its sworn, sometimes sneering, enemies who remain loyal to the polished international imagery of Modernism or prefer to manipulate the Post-Modern currency of a devalued classicism. Begg's success in 'building a new tradition' is certainly problematical, but it is far from trite, its integrity never in doubt.

In addition to its public function which entails a museum, lecture and recital hall, shops and restaurant, the building provides the Friends of the Cathedral with meeting rooms and offices. But perhaps its major achievement is to toughen up the townscape edge of the newly created pedestrian precinct which architects Page and Park have opened up from the great west portal of the Cathedral as far as Castle Street.

4 **Provand's Lordship**
3–7 Castle Street
1471; 1670
Architect: unknown

The oldest house in Glasgow and the only clue to the architectural appearance of the medieval streets – but not a reliable one. The earlier part of the building which faces Castle Street, originally part of St Nicholas's Hospital, must surely have had a less regularized facade (an 18th century renovation may be responsible) while the 'restored' look of the windows is unconvincing. Though later, the more random treatment of the rear elevation with its three crow-stepped gables gives a better idea of the medieval streetscene – even if few houses would have been as substantially rubble-built.

Provand's Lordship was erected as a manse for one of the Cathedral's many serving clergy who, between the second quarter of the 15th century and the Reformation a century or so later, were accommodated here on the hill close to the church and the original centre of town at the Quadrivium, the four-street junction located at today's intersection of High Street and Rottenrow. Rather surprisingly it has survived several centuries of change and now, following a restoration completed in 1983, functions

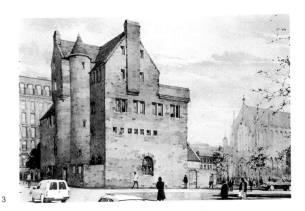

3

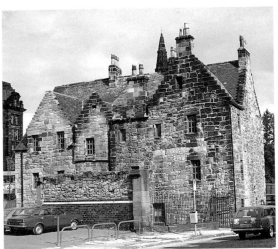

4

as a museum of medieval domestic life in Glasgow. There is a collection of Scottish furniture on view.

Open to the public.

5 Barony Church
Castle Street
1886–90
Architects: J.J. Burnet and J.A. Campbell

On all sides this is a powerfully massed church. To the south-east, where perspective reveals its Early English Gothic T-plan form, a domed corner pier, yawning transept portal and the great Dunblane-derived buttressed gable mark the threshold to worship. Once you are within, the rust stone space soars and flows magnificently – up through sharply pointed arch and elongated lancet, and out from church to halls and ancillary rooms in a fluid sequence of cleverly interrelated planning.

After years of neglect, the deserted church has at last found a new use as the Congregation Hall of the University of Strathclyde.

6 Barony North Church
14–20 Cathedral Square
1878–80
Architect: John Honeyman

In a milieu which, if the bulk of James Miller's Royal Infirmary (1907–14) can be even momentarily ignored, is more Gothic even baronial than classical, this delightfully Italianate church testifies to the all-round skills of the best Victorian architects. Renowned as a scholarly medievalist active in the restoration of Glasgow Cathedral, practised as an innovative designer in cast-iron (see for example the Ca'd'Oro), Honeyman here closes the eastern side of Cathedral Square with a wall, a portal and an almost scenographic display of Italian Renaissance detail. Facing west, raised on a channelled base, are five arched bays separated by advancing columns each with its own projecting entablature capped by statuary and linked by a balustraded eaves. A shapely belfry unbalances the symmetry without giving offence while behind the apsidal chancel the hillside eastern elevation drops dramatically away.

7 Student Housing
University of Strathclyde – Collins Street/Cathedral Street/Rottenrow
1983–90
Architects: G.R.M. Kennedy and Partners

Maintaining street lines and creating an inner campus space of linked courts, this attractive enclave of student accommodation gives strong urban definition to the flanks of Strathclyde University. Four-storey scale and red brick are wholly contextual – some plain, red sandstone, gallery-access tenements of the 1890s, rehabilitated as hostels, have been integrated into the scheme – while the architectural idiom of post-modern Baronialism, entailing rustication, string courses, corbelling and turrets, also responds to local cues.

Murray Hall, on Collins Street, is particularly allusive with formal quotations from Mackintosh's Scotland Street (stair towers) and Glasgow School of Art (entrance light), but Forbes Hall, Rottenrow/Weaver Street, is still more dramatically if less

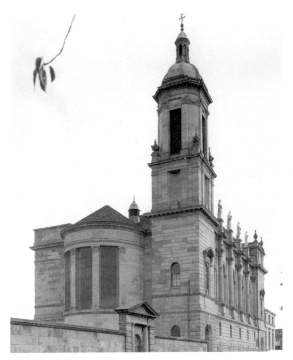

6

7

derivatively Scots. Across the street, following the contours of the hill above High Street, are the latest residences to be built – four energy-conscious blocks soaking up the light from the south through tall slots of glazing.

Despite a too-relaxed suggestion of Frank Lloyd Wright in the Lord Todd building, a student bar and restaurant lying at the centre of the development, and a similar weakening of architectural nerve in courtyard landscaping, there is an urban conviction about this part of Strathclyde's campus which, with the future implementation of Page and Park's master plan and the restoration of Burnet's Barony Church, should effect a coherent transition eastwards from University to Cathedral.

8 **School of Architecture**
University of Strathclyde, 131 Rottenrow
1964–67
Architects: Frank Fielden and Associates
A long Brutalist boat of a building beached on the crest of Rottenrow. Above the recessed but somewhat mannered profile of the ground floor, two storeys of twelve bayed-bays of studio space wrap themselves along a central core of lecture room accommodation like the decks of a liner. Liveried in blue engineering brick and greening copper cladding, the great ship lacks the expected superstructure of bridge and funnel. Instead, a white-sailed flotilla of sloping northlight rooflights flashes a second nautical illusion along the skyline.

The First New Town

9 **City Chambers**
George Square
1882–90
Architect: William Young
Outflanked in municipal patronage by earlier town halls in Paisley and Greenock, Glasgow resolved to outbuild its neighbours. Accordingly, Young's competition-winning design goes for size and lavish grandeur, perhaps a little at the expense of architectural good manners. None the less, this is a splendid pile inventively eclectic with its Italianate sources and packed with fascinating figurative carving.

The city block plan is arranged around a courtyard, each corner is domed and there is a three-tiered pedimented frontispiece, dense with decorative detail, behind which rises a tall axial tower.

The staircases and galleries of the interior are opulently endowed in rich marbles, mosaics and tiles – mercantile and industrial wealth at its most ostentatious. In the great Banqueting Hall the walls carry painted decoration (1899–1902) by the Glasgow Boys.

10 **Glasgow College of Building and Printing**
North Hanover Street/North Frederick Street
1962–64
Architects: Wylie, Shanks and Partners
One of the city's earliest commercial high-rise slabs; thirteen storeys glazed north and south, travertine-clad gables. The influence of Le Corbusier is evident: the lozenge plan derived from St

8

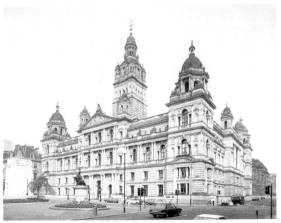

9

Dié or, at greater remove, the Rentenanstalt project for Zürich (1933); the sculptural skyline and massive pilotis from the Unités. Seen from the south, soaring above George Square, the roofs-cape still intrigues, but the entrance groundscape is claustro-phobic and squalid – instead of an open green hillside, a cramped car park and ugly assembly building.

A year earlier the same architects completed the city's Cen-tral College of Commerce and Distribution immediately to the north on Cathedral Street. Materials and mentor were the same, but the urban aggression of its mere seven storeys more muted.

11 Queen Street Station
West George Street/Dundas Street
1878–80
Architect: James Carsewell

Though smaller than either of its two great Victorian rivals, Cen-tral Station or the now-lost St Enoch Station, this is the best of Glasgow's great railway sheds, full of light and structural clarity. Ten bays of 70 ft span lattice bowstring trusses cross the tracks from squat iron columns on either side, some still with their dis-proportionately massive Corinthian capitals free from sanitized cladding in white tiles. To the north the wide bow roof ends in a fan of hanging glazing; to the south, the beauty of the structure is hidden from George Square by the most nondescript con-crete-clad offices (1968–69).

12 Royal Exchange Buildings
Royal Exchange Square
1827–32
Architect: David Hamilton

Royal Exchange Square was one of Glasgow's first Conservation Areas. It is not difficult to see why. The idea of this elegant sym-metrical enclave of Georgian restraint probably belonged to Archibald Elliot junior whose Royal Bank (1827), with its Ionic portico and flanking archways, now acts as propylaea to the Vic-torian city centre to the west. But the Square's success derives as much from David Hamilton's magnificent Exchange filling the space in characteristically Glasgow fashion, its still grander por-tico closing the long vista from Ingram Street.

Behind the immensely civic Corinthian columns of the Queen Street facade lies the Lainshaw (or Cunninghame) Man-sion (1777–80) 'quite encased' by Hamilton in giant order pilasters, entablature and attic, and beyond it the Exchange Hall, maintaining a hefty eaves entablature on giant free-standing columns. Above the pedimented portico rises an attenuated cir-cular temple steeple, Grecian counterpart to the model set in St Andrew's Square almost a century before.

For many years the Exchange was the nerve-centre of Glas-gow's business accommodating the city's earliest telegraph and telephone installations (c.1870) and adapting to internal remod-elling, notably that by Thomson and Menzies in 1903. In 1950 it was converted to house the Stirling Library. Above today's citi-zens, browsing in the great Hall, the richly coffered canopy of Hamilton's segmental vault fortunately remains.

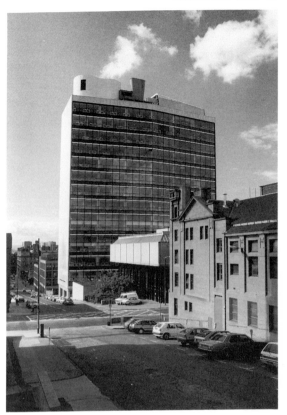

10

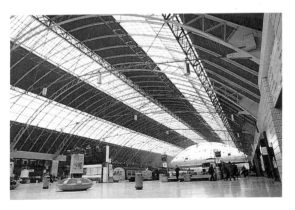

11

13 **The Italian Centre**
John Street/Ingram Street/Cochrane Street
1987–90
Architects: Page and Park

One of a number of city block renewals carried out in Glasgow's Merchant City over recent years, the Italian Centre has transformed a group of warehouse and office buildings (c.1840) fronting three streets just south of the City Chambers (q.v.). Backlands structures have been removed to create an inner courtyard reached through four pends and most of the ten retail units which now take up the street-level accommodation. In the floors above, 32 flats and some 8000 sq ft of office space have been provided.

From a new somewhat top-heavy arched loggia built on the eastern side of the block, café life spills over across the pedestrianized paving of John Street. This café, a restaurant, bistro and wine bar, even the new shops, are all committed to the Italian theme that governs the whole development.

An unusual aspect of the project – a measure of the enlightened policy pursued by the developer – is the close collaboration which from the start has prevailed between the architect and those artists and craftsmen commissioned to enrich the Italian atmosphere. Integrated into the mise en scène are three exterior sculptures of Mercury created in classical style at twice life size by Sandy Stoddart, metalwork figures of Apollo and Dionysius by Jack Sloan and, in the restaurant, a mural by Ian McCulloch depicting 'The Rise and Fall of Rome'.

14 **Trades Hall**
85–91 Glassford Street
1791–94
Architect: Robert Adam

Glasgow's 'Guildhall', built as the meeting-place of the city's fourteen trade incorporations, now testifies alone to the considerable contribution which the Adam practice made to the stylish city of the 1790s. The street front formula – rusticated base, Venetian windows, central dome – reiterates a compressed version of his Royal Infirmary (1792–94) though it does not quite attain the elegance of the Assembly Rooms (1796–98) which followed posthumously. Meddling amendments to the facade and a wholly reworked interior aggravate the sense of loss. For all that, there is a proud symmetry about the design which, locked into the recurrent point de vue option of the First New Town, suitably confronts the nine bay front of the former Merchants' House down the short line of Garth Street: trade and commerce in municipal axis.

Numerous alterations have occurred over the Trades Hall's 200 year history, the most significant being extensive internal reconstruction by James Sellars in 1887–88 and a refacing of the facade by John Keppie in 1927.

15 **Glassford Court**
37–41 Glassford Street
1987–88
Architects: McGurn, Logan, Duncan and Opfer

This five-storey Merchant City infill, comprising four shop units with 15 flats above, is the second phase of a project begun in 1986 in the residential conversion of the adjacent seven-storey

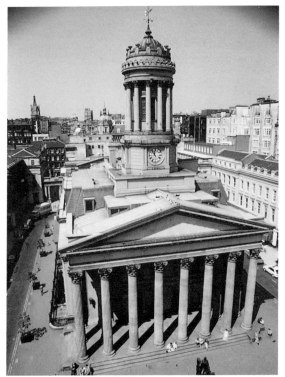

12

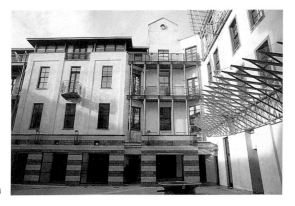

13

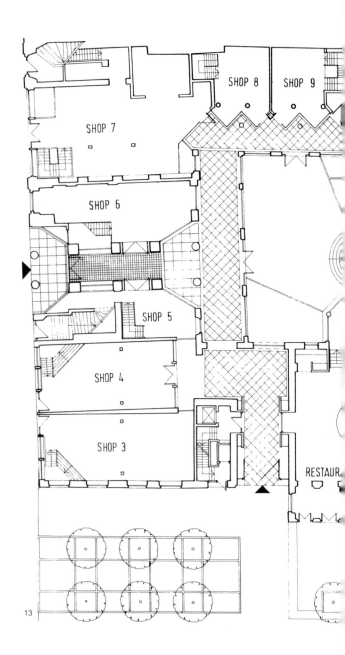

SHOP 8

SHOP 9

SHOP 7

SHOP 6

SHOP 5

SHOP 4

SHOP 3

RESTAUR.

13

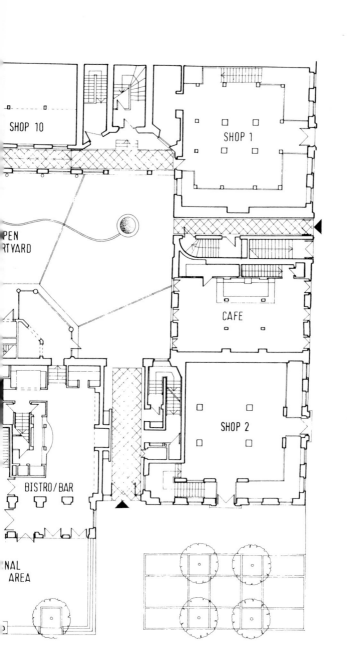

warehouse. The two are integrated in terms of circulation, while red brick establishes colour continuity with the red sandstone of the former warehouse; 37–41, however, maintains its own separate formal integrity.

Symmetrically composed, the building is, rather surprisingly, four bays wide, yet, with considerable panache, it contrives a classically axial organization based not on the customary central void of door or window but on the negative solid of a structural support zone. This is done subtly by clever inner inflections in the facade fenestration but more boldly by a shallow eaves pediment which surmounts a blind tympanum plane and bracketed balcony. Some distant allusion to Adam's nearby Trades Hall (q.v.) can be sensed.

16 **Hutchesons' Hospital**
158 Ingram Street/John Street
1802–05
Architect: David Hamilton
Interior recast by John Baird, 1876

At the end of the 18th century the patrons of the Hutcheson charitable foundation moved from their mid-17th century Trongate premises into the city's First New Town. Hutcheson Street was driven north and opposite its junction with Ingram Street a corner site was obtained.

Hamilton conceived the new building as a steepled cube with two exposed street faces. On Ingram Street the importance of a rather mean main entrance was saved by the recessed bays of a high-windowed piano nobile fronting the first-floor hall and, still more dramatically, by the axial emphasis of the city church spire above. Rusticated plinth, eaves entablature and attic storey continued on the John Street elevation, a clever if superficial composition largely unrelated to the plan behind and a little embarrassed by an off-centre side entrance.

Hamilton's details, Adam-derived and Soane-like, were up to the minute. All that remained from the former late medieval building were James Colquhoun's 1649 statues of the Hutcheson brothers incorporated in the flanking niches of the Ingram Street facade.

In 1876 John Baird II reconstructed the interiors. More recently, these have been sumptuously restored by Jack Notman.

The building is now occupied by the National Trust for Scotland.

Open to the public.

17 **Ingram Square**
Wilson Street/Brunswick Street/Ingram Street/Candleriggs
1984–89
Architects: Elder and Cannon

This is a complex development comprising the extensive rehabilitation of former warehousing to residential use, some new-build infill and the creation of two new inner courts, all within a single block of the Merchant City grid. On the north side is Robert Billings's Houndsditch Building (1854) converted to private flats; across the middle, students' housing; in Candleriggs, a new five-storeyed pedimented tenement accessed by rear galleries; and, at the south-west, a complicated corner assemblage of shops, flats and penthouse eyrie.

15

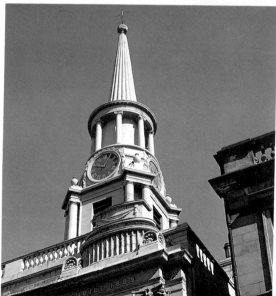

16

The formal language is free-wheeling Post-Modern classicism admirably suited to the urban context, as is the use of polychromatic brick and stone. Ironwork trim and coloured banding provide decorative textural relief. A keen observation of the street scene is evident; so, too, a light almost whimsical touch which banishes leaden pastiche. Only perhaps in the tall tube tower at the corner of Wilson Street have things gone too far.

18 The Daily Express Building
Albion Street
1936–39
Architect: Sir E. Owen Williams
Glasgow has no more than a handful of between-the-wars buildings of any quality. This newspaper office, originally built for the Daily Express proprietors and now serving the Glasgow Herald, is the best of the few.

Begun as a sleek four-storey block located between Albion Street and the ancient graveyard behind St David's Ramshorn Church, it was almost immediately extended south with a higher set back tower containing offices and services. The structure is a reinforced concrete frame more evident on the secluded western side than on the street facade. There, a curtain wall of clear and black glass hangs over the frame, a polished plane of fenêtres en longueur, animated, especially at night, by the frenetic life of the building.

Williams, an engineer, produced the same sophisticated house-style for the Express offices in London and Manchester; perhaps the closest British architecture came to that machine-like precision fabrication seen in the best of Dutch, Swedish or Czech Modernism.

19 Bell Street Warehouse
105–69 Bell Street
1882–83
Architect: unknown
Conversion by James Cunning Young and Associates (1984–88)
The sustained energy of Glasgow's 19th century expansion survives best in its great street ranges of tenements and warehouses. Nowhere is the city's aggressive mercantile confidence more physically present than in the six-storey mural mass of this former railway warehouse.

It may be true to describe the facades as 'completely unarticulated' but, if there is no stylistic sophistication, there is raw architectonic power. Solid dominates over void, all-over rustication produces a high-rise rampart of a building, while the slow subtle curve of the street seems to lend the conception a relentless infinity.

Not perhaps the most user-friendly of places, the warehouse has been converted into flats for the ever-increasing population of the revived Merchant City. To the north, more new housing – inevitably insipid by comparison – will follow.

18

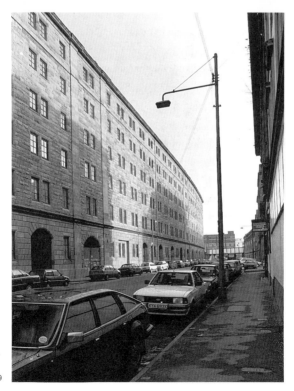

19

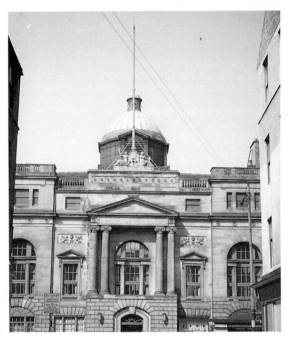

14

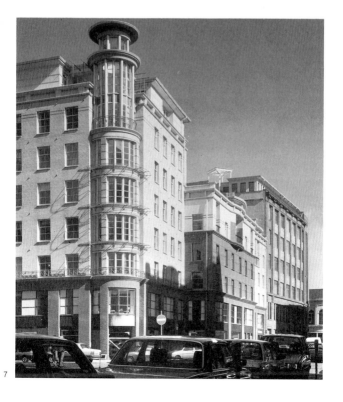

7

Trongate and Clydeside

20 **The Tolbooth**
Trongate
1625–27
Architect: John Boyd

All that remains of Glasgow's late medieval Town House or Tolbooth is this seven-storeyed square-plan tower with its turreted crown. The steeple is plain save for string courses at each level and some Netherlandish strapwork ornament over the small windows centrally placed in three of the facades.

Until its demolition in 1921, the Town House itself stood hard against the steeple's western side fronting Trongate. Originally a severe, five-storeyed, five-bayed building, turreted and crenellated but with minimal classical detail, it had been gothicized in 1814 – though with comparable reserve – by David Hamilton. The balustraded concave quadrant of offices, built in 1922 to nudge traffic round the tall tower into High Street, is by A. Graham Henderson.

Across the street is the Mercat Cross, 1930, designed in late medieval Scots style by Edith Burnet Hughes, to replace one removed in 1659.

21 **Offices**
74–92 Trongate
1854
Architect: John T. Rochead

Following the publication of Robert Billings's four volumes of The Baronial and Ecclesiastical Antiquities of Scotland (1845–52) many Scottish architects extended their repertoire to include a strongly national historicism. Rochead was one of these. At the end of the decade he would design the Wallace Monument at Stirling, a project eminently suited to the new idiom since it commemorated one of Scotland's great national heroes. But this earlier commission for the City of Glasgow Bank was doubly unusual: in the first place, it was at the heart of Glasgow, a city which proved less enamoured with the fashion than, for example, the country's capital, Edinburgh; secondly, it applied the new style to a commercial brief with no obvious programmatic allusion to nationalist form.

It is an exuberant mixture of baronial elements with Elizabethan and Jacobean seasoning for added zest: over-rich in ingredients perhaps, indigestible to some, but a unique contribution to the streetscape feast around Glasgow Cross.

22 **Tron Steeple and Theatre**
71 Trongate
c.1592–95 (tower); 1630–36 (spire); 1793–94 (church)
Architects: McGurn, Logan and Duncan

The present building, now the Tron Theatre, is the third church on the site. Designed by James Adam with little architectural pretension beyond a fine internal plastered dome, it replaced a city kirk of the late 16th century which was itself a reconstruction of the medieval collegiate church of St Mary and St Anne. The 1590s tower, given a spire in 1630–36 somewhat in emulation of the Cathedral, remains an important ingredient in the urban scene around Glasgow Cross, all the more intimately involved in the streetscape by being penetrated by a four-centre arched

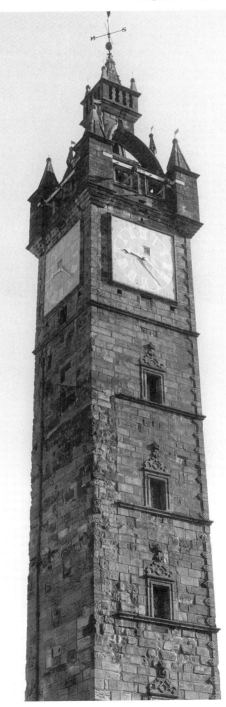

walkway by John Carrick in 1855. To allow pedestrians to pass through, Carrick had the old public weighbeam, or tron, which stood in this location, removed.

Turning the corner into Chisholm Street is a heavily rusticated baroque screen wall built by J.J. Burnet, 1899–1900, to screen ventilation to the railway track running below street level.

After much neglect, church and outbuildings were converted to a theatre and theatre club in the early 1980s.

23 Justiciary Court House
Saltmarket
1807–14
Architect: William Stark

Although the conception belongs to Stark – 'the best modern architect that Scotland has produced', Lord Cockburn called him – the building has been twice remodelled (1845 and 1859) and virtually rebuilt in 1910–13 by J.H. Craigie. But while the flanks and end pavilions no longer have the coolness or the unifying French channelling of the original design, Stark's splendid Doric portico still exerts its commanding presence eastwards into Glasgow Green. Modelled on the Theseion in Athens, perhaps a consequence of Stark's friendship with Lord Elgin, it contests the claim to being the first such Grecian portico on a public building in Britain with Sir Robert Smirke's Covent Garden Theatre in London.

24 Briggait Centre
Briggait/Clyde Street
1872–73; 1886; 1903
Architects: Clarke and Bell
Rehabilitation and conversion by ASSIST (1983–86)

On Clydeside and on the ancient Briggait (or Bridgegate) the building's facades are essentially portals, each a lavishly decorated double-gated Doric screen. The coupled columns are French in character but the swagged porthole motifs, which run in line with the entrance and exit archways, come, appropriately enough, from Michelangelo's Porta Pia. Inside, through fine cast-iron gates, is a cast-iron structure branching up to enclose the high roof-lit galleried space of Glasgow's Fish Market. Inside, too, is the oddly trapped base of the Merchants' Steeple (1665), the last vestige of the city's medieval Guildhall (1659). Above the roof it rises in three balconied stages providing progressively better platforms for viewing activities downriver to the west.

ASSIST's crisp metal-tech conversion of the market hall to shops and cafés saved structure and space but came perhaps a year or two too soon. Continued revival in the Merchant City and recent shopping investment south of the Trongate may, with luck, restore its commercial viability.

25 King's Court
King Street/Osborne Street
1988–89
Architects: Comprehensive Design

In the acute angle between two converging railway viaducts, a new public space fronting King Street has been created. Two open steel-columned aisles carrying small bow trusses and a glazed tunnel roof run parallel to the old arched vaults which support the disused tracks above. Beneath the arches are six

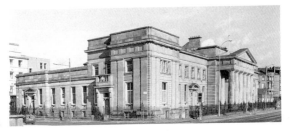

23

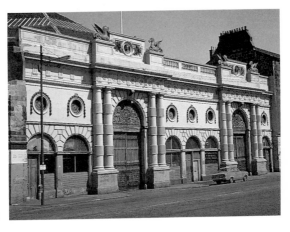

24

workshops and ten retail units gaily framed in polychromatic brick; at the junction of the tracks is a corner café capped by a raised brick drum and glazed cupola cone. The paved forecourt may be optimistically intended for plein air relaxation but the light-hearted colours – sky blue and plum – and the lightweight architecture of glass and metal fittingly evoke something of the holiday spirit of Edwardian stations.

26 Carrick Quay Housing
Clyde Street/Stockwell Street
1989–90
Architects: Davis Duncan Partnership

On a site once occupied by two of the finest Palladian mansions of 18th century Glasgow, almost a hundred flats and penthouse maisonettes set a new nautical style for riverside city living in the 21st century. Berthed across the street from the quayside is a red and buff brick hull of housing, its flat facade enlivened by lightweight steel masting and five tiers of bowed balconies. A continuous lightly railed terrace marks the eaves-level deck. Above and behind rises a white superstructure of two-storeyed glazed penthouses. There is even a suggestion of a skyline funnel in the hollow half-tube form which shoots up from the cylindrical corner to Stockwell Street.

The architects claim to respect the Glasgow traditions of tenement, warehouse and shipping. There is no doubting the last of the three: planar forms and a pronounced horizontality in the proportioning of facades, especially effective behind the balcony rigging applied along Clyde Street, are certainly evocative of the white maritime style of the 1920s and 1930s. On the east side of Stockwell Street, however, a dramatically vertical flatted architecture – tenement and warehouse – might have occasioned a more contextual cross-street response.

27 St Andrew's Cathedral
Clyde Street/Dunlop Street
1814–17; enlarged 1870, 1890–92
Architect: James Gillespie Graham

Riverside Gothic Revival, the first neo-Gothic church in Glasgow: set beside some of the Palladian mansions of the city's merchant aristocracy (long since demolished), Gillespie Graham's Roman Catholic chapel, proudly gable-on to the Clyde, symbolized a new toleration in matters religious and stylistic.

Two octagonal buttresses, lanceted and castellated, hold the apex niche for St Andrew and the nave window's Late Decorated tracery, 'its segments pushing out in all directions like splitting amoebae', in a tall Perpendicular sandwich, while high crocketed finials surmount the outer flanks of the aisles. There is a fine interior of plaster vaulting.

Immediately to the west, creating a small courtyard recessed from the street, are Nicholson and Jacobsen's Archdiocesan Offices (1987–88), six storeys of mirror-glazed curtain drawn across an earlier structure. An easy option, perhaps, but decidedly more urban than the low-scale buildings of Cathedral House (1986) which cluster incongruously around the Cathedral chancel across the street from the sloped bulk of the St Enoch Centre (q.v.).

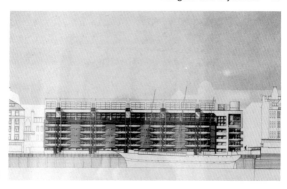

26

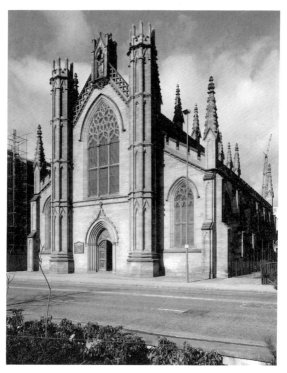

27

28 **Pier 39**
Custom House Quay, Clyde Street
1988
Architects: McDonald Williams Partnership

A conservatory café rigged for riparian leisure. From the street a symmetrically placed entrance leads between blockwork flanks to a light-filled saloon deck overlooking the river to the south. Anti-sun glass does something to cut the glare but the large drapes of white sailcloth slung below the glazed roof slopes are an added and altogether more practically – and symbolically – effective solution. The structure is steel, a castellated ridge beam cantilevered almost sprit-like through each glass gable while projecting exhaust duct tubes add a further nautical image. Below decks, opening on to the quayside walkway, is an esplanade bar.

Immediately to the east on Clyde Street stands the triumphal Ionic arch of Alexander Kirkland's Suspension Bridge of 1851, an impressive ashlar gateway to the south bank suburbs but absurdly blocked on its access axis from the north.

29 **Warehouse**
118–20 Howard Street
1903–05
Architect: John Gibb Morton

No longer confined by its once tight-walled urban streetscape, this five-storey warehouse in red sandstone ashlar has all but lost the (infill) raison d'être for its tall symmetrical facade. None the less, its Art Nouveau architecture remains: channelled 'buttresses' rising left and right of a central bay which becomes bowed on the upper storeys, pairs of elongated windows separated by wafer-thin stone mullions, wide-lipped sills, and the pressed-out profiles of simple eaves cornices – all bespeak that so-called 'Glasgow Style' of the Edwardian city. But, if there are hints of Mackintosh and Salmon in all this, the glazed warehouse wall springs just as much from the provenance of Burnet and Campbell.

Behind the stone facade, which steps back subtly as the rising wall thins, is the logic of the structural frame, still transitional, however, with its cast-iron columns, rolled steel beams and timber floors.

Surprisingly, the original design of the street-level storey bore no visual relationship to the gridded composition of the floors above – a deficiency which subsequent shopfront alterations have done nothing to remedy.

30 **St Enoch Centre**
St Enoch Square/Howard Street/Osborne Street
1981–89
Architects: Reiach and Hall with Gollins Melvin Ward Partnership

It may seem strange that Glasgow should tear down the glazed arches of St Enoch Station railway shed (1875–79) to replace them with the 'raked glass tent' of this huge shopping shed. But 'beneficial demolitions' – to use the Futurists' phrase – have always been part of the city's tradition: Glasgow's vaunted Victorian centre rose, after all, from Georgian and medieval rubble.

The project is immense – 6.5 city-centre acres given over to low-level retail shopping, a food court and ice rink. A seven-tiered car-park stack runs along the north of the site. Against this

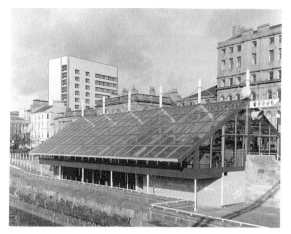

28

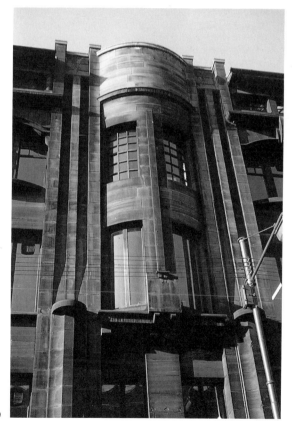

29

lean long lattice trusses rising to 30 m above the shopping mall carry 'the largest glass roof in Europe'. The white structure itself is spectacular, the plant-hung shopfitters' clutter below less worthy. Solar energy plays a major part in the heating and in summer, shading and louvre ventilation respond automatically to the conditions.

The Centre is a giant simply unable to prevent its bulk bruising the urban fabric. St Enoch Square suffers most. But Osborne Street gains unexpectedly from the Metropolis imagery of its tubed facade.

31 **Royal Bank of Scotland**
Trongate/Glassford Street
1901–03
Architect: Thomas P. Marwick

A tower house of finance built for the National Bank of Scotland, this castle on the corner is full of Scots Renaissance invention. From street-level windowed arcades that recall the 'piazzas' of old Glasgow, walls rise through high storeys of banded rustication. But, appropriately enough, the architectural action is saved for the skyline – Netherlandish gables set between tall dome-topped tourelles fronting a steeply pitched flat-topped pyramid roof. To complete the nationalist fervour a plaque records Prince Charles Edward Stuart's 1745 stopover at the nearby Shawfield Mansion.

Though the Trongate is one of the city's oldest thoroughfares, Glassford Street was formed as late as 1792. Before that the Shawfield Mansion stood opposite the head of Stockwell Street. Colen Campbell's plain but erudite design of 1711, featured in Vitruvius Britannicus, was the first of several such severely symmetrical residences to be built by the Tobacco Lord dynasties in the 18th century Merchant City – early enough indeed to point to 'a Scottish Origin for English Palladianism'.

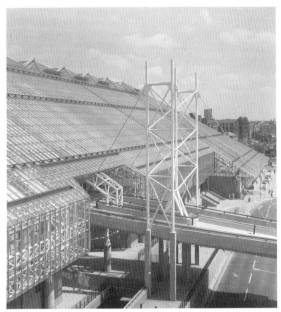

30

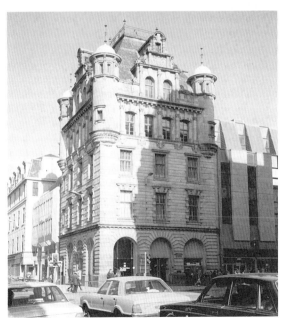

31

The Victorian City

Buchanan Street

32 **Argyle Arcade**
98–102 Argyle Street/28–32 Buchanan Street
1827
Architect: John Baird

In Glasgow there are no grand galleria. Surprising perhaps in a city where Victorian commerce prospered; surprising, too, in a city where wind and rain so often sweep the streets. There is only this single 19th century street-to-street arcade. Fortunately, it is a delight.

The scale is almost intimate – or seems so after the canyon-like streets; the detail delicately repetitive. Left and right, above the continuous fascias of the shops which line the right-angled shortcut route, are framed windowed walls above which, from dentilled cornices, spring the thin hammer-beam trusses which support the spars of a glazed saddle-back roof. Light floods down. Structure seems all but eliminated. There is here an intimation of that paring elegance which Baird would later achieve to world acclaim in Gardner's Warehouse (q.v.).

33 **Prince's Square**
Buchanan Street
c.1845; 1985–87
Architects: John Baird I; Hugh Martin & Partners with The Design Solution

In what was once a somewhat dull open courtyard behind Baird's long plain Prince of Wales Buildings (1854) on the east side of Buchanan Street, one of Glasgow's most exciting new spaces attracts the city's beau monde. Beneath glazed arched canopies on the street front, tight passageways spill out into a tall white-ribbed symmetrically organized void: memories of market halls stir, but the ambiance is more deliberately theatrical so that the shopper feels as if surrounded by the balconied bars of some vast opera house foyer. This is a place to parade as much as shop, whether on the baroque flights and landings of the grand central staircase, along the curving galleries, on the escalators or in the glazed sedan chairs of two open-framed lifts which rise slowly through four storeys. Against the background of the original stone walls of the courtyard elevations, somewhat remodelled on the eastern side, a series of formal patterns play their decorative games – white rectangular grids around the lifts distil the horizontals and verticals of galleries and clustered

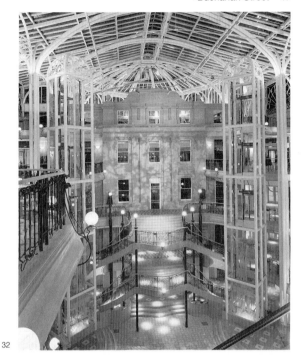

32

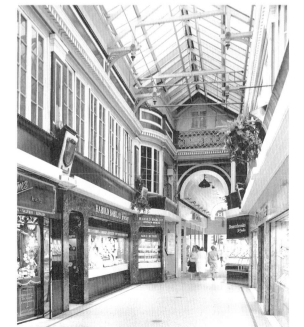

33

columns; organic contortions in the ironwork balustrades become progressively more riotous with each floor level; and, above, a skeletal net of round-arched geometries defines the glazed dome of the roof.

34 Royal Bank
8–16 Gordon Street
1853–58
Architect: David Rhind

Rhind out of Raphael – Edinburgh architect, Roman style. An urban palazzo built as the Commercial Bank's headquarters in Glasgow. The three-storey facade, framed vertically by broad bands of vermiculated rustication, divides into three zones, the middle carried up into a pavilion-roofed attic storey, almost a rooftop loggia of Corinthian columns. Each zone has its central focus, a segmentally pedimented aedicule at first floor. This stress is repeated in the main entrance at the centre of the arcuated ground storey but not in the side wings where a deliberate inward inflection in the placing of subsidiary entrances is contrived.

Sculptured work by A. Handyside Ritchie. Interior replaced by James McCallum in 1937. The extension to the east (1886–88), domed on the corner to Buchanan Street but, despite its ostensible deference, lacking the irreproachable judgement of Rhind's design, is by A. Sydney Mitchell.

35 Clydesdale Bank
30–40 St Vincent Place
1870–74
Architect: John Burnet

Despite its lopsided facade frustrated by force majeure – completion of the missing two bays and end pavilion to the east was precluded by the erection of the Evening Citizen building – Burnet's Venetian exuberance is powerfully ordered and rich in architectural detail and street-wall texture. Above an arched heavily rusticated ground storey, columns and pilasters are twinned or tripled to define structural bays, entablatures pushed forward for added stress. A baroque frontispiece is enlivened as much by Burnet's chiaroscuro as by John Mossman's statuary. At the eaves, on either side of a central split and scrolled pediment, run balustrades repeating those at pavement level but crested with strange acorn-like urns.

The double-height Banking Hall is less architecturally satisfying. Its arched and columned perimeter, cooler than the vigorous exterior, seems ill at ease beneath a flattened segmental vault. In the middle of this deeply coffered ceiling a glazed cupola sits no less awkwardly. For all that, the Hall is spacious and impressive, splendidly restored (1978–80) by Jack Notman.

36 Clydesdale Bank
150 Buchanan Street
1980–81
Architects: G.D. Lodge and Partners

For 200 years bank architecture has been a rich ingredient in the city's street-scene mix. But taste and wealth do not always go together. Here a rather over-rouged opulence of pink and rust granite prevails, there is much shiny trim of lip-liner chrome and a six-storey wall of mirrors looking back at the city through rose-

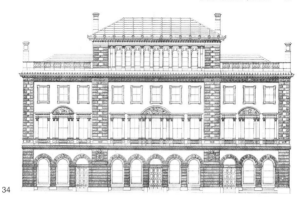

34

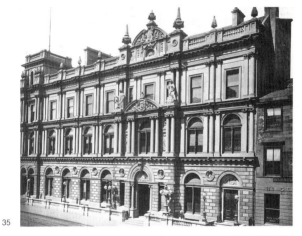

35

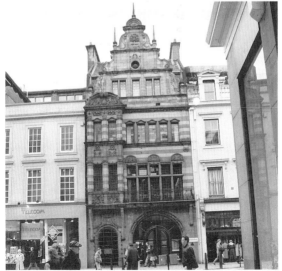

36

tinted glass with a twisted reflective smile.

This wall is strongly profiled: bold canted bays at street level, twinned square bays in the floor above, a jutting mullioned slab three floors high and a mansardic attic reversing the oblique projection beneath the offices below. Form and finish repeat relentlessly on each facade, only the merest corner recess indicating an entrance.

37 Stock Exchange

159 Buchanan Street/Nelson Mandela Place
1875–77; 1894–98; 1904
Architects: John Burnet, senior; J.J. Burnet

'Glasgow's only example of municipal Gothic' may well have been a reduced version of William Burges's unsuccessful competition design for the London Law Courts. Whatever name can be put to the style – North-Italian Gothic, Franco-Italian Gothic or simply 'well-mixed' Gothic – this is the exception which breaks the ubiquitously classical rule of Glasgow's streets. And it does it with vigorous zest! Not all is satisfactory: a gabled corner to the north weighs awkwardly on the facade screen below, while elevational alignments jump with J.J. Burnet's western additions. None the less, a busy roofscape, corbelled cornice and the reverberating motif of the pointed arch hold things together.

Between 1969 and 1971 the entire interior was removed and redeveloped by Baron Bercott and Associates, all facades being carefully preserved.

38 St George's Tron Church

165 Buchanan Street/Nelson Mandela Place
1807–09
Architect: William Stark

Farthest west of the Merchant City's point-de-vue buildings, Stark's splendidly vertical City Church acts as a visual pinion at the transition between Glasgow's 18th and 19th century expansion. To the older east, it presents an abstemiously orthodox three-bay classical front, its central pilasters threaded up into the angle-buttressed corners of a still more severe steeple which terminates in tempietto crown and stabbing skyline obelisks. Filling the square behind the towered facade, the church itself, the work of James Cleland not Stark, is a simple unelaborated affair; yet even its pediment-like gable also serves to close the vista from the west in the long perspective that runs downhill through the city's Second New Town of Blythswood. Not surprisingly, in Cleland's hands the galleried interior is plain in the extreme.

39 Royal Faculty of Procurators

62–68 West George Street/Nelson Mandela Place/
West Nile Street
1854–56
Architect: Charles Wilson

Wilson at his most voluptuously Italianate. A rich two-tiered cake topped off with a creamy eaves frieze and iced with lashings of Venetian fondant. Spalling paint seems only to add an ambivalent patina of flakey patisserie.

On the first floor is the library, its interior shining with polished wood, square marbled columns and gilded mouldings.

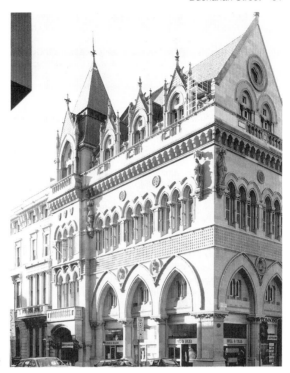

37

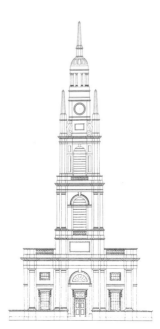

38

This is the intellectual sanctuary of Glasgow's legal profession. The central nave, lit by Palladian windows east and west, is flanked through arched screens by vaulted aisles. Left and right are the book stacks set in a series of quiet study chapels. This is indeed 'the most handsome room of its date in the City centre'.

40 The Athenaeum
60 Nelson Mandela Place
1886
Architect: J.J. Burnet

A crisp academic severity, abandoned in Burnet's later more inventive and ebullient work, gives the facade a classical restraint scarcely expected in the 1880s.

Above a storey-and-a-half high plinth of channelled ashlar, a triple-arched piano nobile, punctuated by Ionic columns, fronts a centrally located library. In the attic, on the advancing entablatures of these columns, stand four full-figure statues by John Mossman – Reynolds, Wren, Purcell and Flaxman. Balanced left and right of the half-glazed triumphal arch motif are narrower marginal stair zones, ingeniously lit. The symmetry of the elevation is repeated through the library foyer and hall of the first floor and in the classrooms of the floors above. But Burnet's decision to place stairs and entrances on the flanks inevitably produces the dilemma of duality, disturbingly resolved by giving the western entrance an architectural precedence which the compositional order of the facade cannot justify.

Begun as a centre of adult education and recreation to fill the gap between the Mechanics' Institute and University, the Athenaeum acquired a music school in 1890, added drama in 1950 and became the Royal Scottish Academy of Music and Drama in 1968. Some two decades later the RSAMD moved to new premises in Renfrew Street (q.v.), leaving the Athenaeum building with a problematical future.

Sauchiehall Street

41 Glasgow Royal Concert Hall
Buchanan Street/Sauchiehall Street/West Nile Street/
Parliamentary Road
1987–90
Architects: Sir Leslie Martin (original design)
Robert Matthew, Johnson-Marshall (realization)

Glasgow has had to wait a long time for an international standard concert hall to replace James Sellars' St Andrew's Halls (1873–77) which burnt out in 1962. It shows. Delay and compromise are difficult to disguise. What emerges is a piece of stripped-down classicism that makes Bucharest look interesting.

Located at the right-angled junction of two of Glasgow's principal shopping streets and close to the disintegrating northern edge of the densely built-up inner city, the site could scarcely be more critical. Martin's solution is an L-plan – auditorium to the west, shopping complex (yet to be built) to the south – hinged around a circular forecourt. Views down Sauchiehall Street and up Buchanan Street, the latter focused on the concave main entrance front with almost totalitarian symmetry, lock into this keyhole piazza. Along the south side of the Concert Hall is a

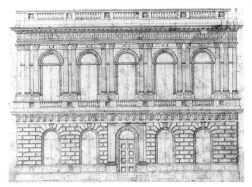

39

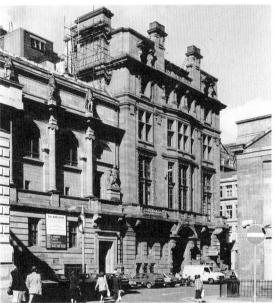

40

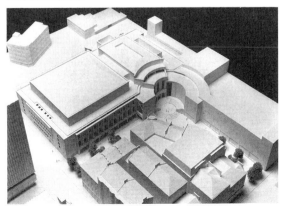

41

giant order peristyle, minimally advanced from a windowed wall and meaninglessly raised above street level; to the north, a lifeless podium carries a similar screen relieved only by a vast porte-cochère set on the axis of the main Buchanan Street entrance. Everything is in a blanched buff sandstone.

The auditorium, a splayed rectangle with a horseshoe balcony that meets raised choir seating surrounding flexibly designed stage arrangements, seats almost 2500. There are bars, exhibition areas, a restaurant and a conference and banqueting suite.

42 **Orient House**
16 McPhater Street
1892–95
Architect: William J. Anderson

Like Napier House in Govan (q.v.), also by Anderson, this attractively incongruous four-storey warehouse combines structural innovation with a stylistic licence that amounts to insouciance. Floored in reinforced concrete and framed in steel, the main bulk of the building, seven bays long by two deep, is pinned at the north-west by a square pyramid-roofed tower that might be the work of a medieval Voysey and at the south-east by the tympanun-topped frontispiece of some classically inclined 1930s cinema. A reckless sense of composition prevails, more Roxy than Colosseum, so that, despite a structural regularity marked by arcuated piers repeating along the facades, the abrupt planar juxtaposition with such dissimilar end features, the agitated castellated skyline and the light-colouring of the harled walls capture the attention with embarrassing success.

43 **Royal Scottish Academy of Music and Drama**
Renfrew Street/Hope Street
1982–87
Architects: Sir Leslie Martin with Ivor Richards
executant architects: William Nimmo and Partners

When, in the early 1980s, the RSAMD was able to contemplate a move from original and adapted premises just off Buchanan Street, the true functional needs of its two teaching schools were revealed as a complex and demanding brief. On paper the planning has been elegantly solved: three separate auditoria placed in line are nested in an L-shaped bed of accommodation given over to teaching, practice, exhibition and administration. On the ground this makes for corridor access problems.

Unfortunately, the urban form of this three-storey ochre brick building is much less successful. A deeply pierced peristyle screen, contrived to present the building to the two streets of its corner site, is no more than a formalist device; a splayed corner has no architectural significance and little justification; while the setting back of the Hope Street facade is an affront to a downtown street. Only at the entrance on Renfrew Street, where a broad flight of steps gives some civic presence, is there any suggestion that this is in fact home to much of the city's thriving cultural life.

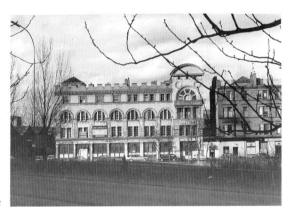

42

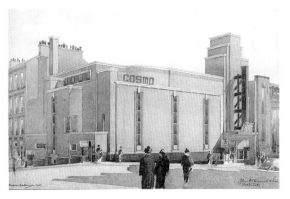

44

44 **Glasgow Film Theatre**
Rose Street/Renfrew Street
1938–39
Architect: William J. Anderson II
of John McKissack and Sons

Once rich in its 1930s cinema architecture, Glasgow has little left of this dream-world of the dark. Even this cosy city-centre picture-house – the 'Cosmo', as it was known to a generation of precociously sophisticated Glaswegians who wanted to see foreign films and smoke Gauloises – has lost its stream-lined Moderne interiors. Gone, too, is the original fan-shaped auditorium with its unexpected section ramping up towards the screen. However competently executed, its later conversions never recaptured the period frisson of the past.

Fortunately, the exterior is still almost intact: a street-corner box in warm brown facing brick with peach and cream faience trim. Strong horizontal recesses, vertical slots and an entrance tower of recessing planes are all decidedly Dudok Dutch in derivation.

45 **Willow Tea Rooms**
217 Sauchiehall Street
1902–04
Architect: Charles Rennie Mackintosh
restoration by Geoffrey Wimpenny of Keppie, Henderson and Partners (1979–80)

This is the single remaining example of Mackintosh's Tea Rooms for Kate Cranston. At Buchanan Street his mural has gone, at Ingram Street there is nothing, at Argyle Street some meagre carving only. But here all is restored – albeit to new use. Yet even behind the rather restless sparkle of jewellery the intriguing spatial tricks of this intimate interior can be found and enjoyed and there is still time and opportunity for tea in the Room de Luxe.

To the street, the engagingly gawky facade shows Mackintosh's typically perverse manipulation of formal axes and balance. But against the white wall of glitter of glass and mirror, the square patterning of astragal grids and stencilled margins, and the delicate ironwork ornament seem to overcome the compositional conundrum. Were it a coffee shop we might be in Vienna.

46 **Grecian Building**
336–56 Sauchiehall Street
1865
Architect: Alexander Thomson
restoration by Boswell, Mitchell & Johnston (1988–89)

Thomson's facade formula for the urban warehouse nowhere attains greater formal or structural clarity, now all the more explicit in a recent restoration by Boswell, Mitchell & Johnston. First comes a ground floor of square-framed glazed shops; next, a piano nobile of tall windowed aedicules standing 2:1 in width with the shops below; finally, a long low eaves gallery glazed behind tubby Egyptian columns which mushroom up between the aedicules below. Above all this is the uninterrupted unifying extension of the eaves entablature.

But here there is a stronger than usual centrality to the composition: solid book-end bays, their raised attics crested with 'a form of pediment', stop the 13-bay run of the framed facade, while a tall Grecian door marks the central entrance to the upper

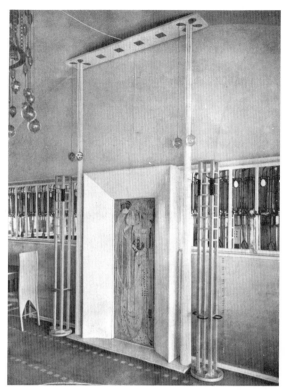

45

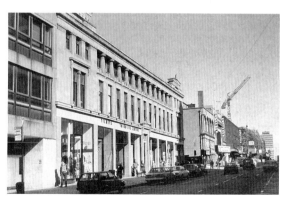

46

floors. And the magical precision of Thomson's neo-Grec detail is here, too, densely packed into the upper zones of the building, engraved with runic intensity into its lithic fabric.

47 Glasgow School of Art
167 Renfrew Street
1897–99; 1907–09
Architect: Charles Rennie Mackintosh

The secret of Mackintosh's 'Masterwork' is its creative synthesis of opposites – austere and delicate, dark and bright, national and international, derivative yet innovative – the dialectics of the design proved endlessly fertile. To the north, full of light from their great grid windows, are studios. To the south, the building is a harled fortress, its gaunt walls sparingly pierced save for a sun-filled parapet gallery, the 'hen run'. On the east, it begins as a turreted stone tower house. On the west, it ends in tumbling banners of coruscating glass. 'Seminal building' it may be but the greatness of Mackintosh's work is less referential than experiential. Every visit reveals some new delight of detail; it is a lasting joy.

48 Breadalbane Terrace
97–113 Hill Street
1845–46; 1855–56
Architect: Charles Wilson

Though the gridded street pattern of the Second New Town continued uninterrupted over the rising ground north of Sauchiehall Street, Garnethill developed none of the orchestrated terrace architecture built on Blythswood Hill. Instead, the feeling was more suburban, with small mansion houses in leafy hillside gardens. A few can still be found.

By mid-century tenements were appearing. Breadalbane Terrace, built in two stages, has almost as much architectural presence as Wilson's contemporary terraces on Park Hill (q.v.): at the head of short flying stairs are square-columned balustraded porches; at first floor, consoled windows alternately pedimented in triangles and segments; and on the top floor a pronounced horizontality given by sill-line string course, eaves cornice and balustrade. On the rear elevation Wilson introduced the bow window to Glasgow (1845), only daring to use it on the street facade at La Belle Place a decade later.

Not far away at 145 Buccleuch Street is the National Trust for Scotland's Tenement House (1892), a fascinating introduction to Glasgow's life-style 100 years ago. Open to the public.

49 Baird Hall
Sauchiehall Street/Garnet Street
1937–38
Architects: Weddell and Inglis

A city hotel given cinema-style symmetry. At the centre of a wide faience front is a triple-finned core (once scarlet and black) on either side of which bulbous bow window forms rise to become rooftop conning-towers each with its own flagpole. All this helps reduce the sheer bulk of the building otherwise evident in the massive side elevation on Garnet Street.

The building, tallest in Glasgow between the wars, was erected as the Beresford Hotel for the 1938 Empire Exhibition. It later served as offices and now does duty as a students' hostel

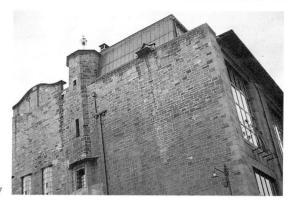

47

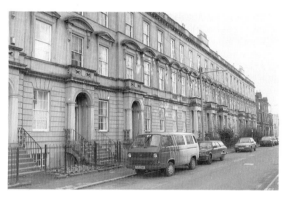

48

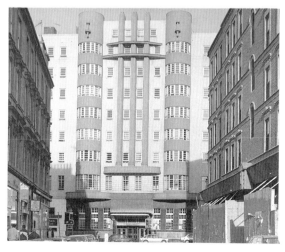

49

for the University of Strathclyde. Its streamlined interiors preserve something of the mannered modishness, if not now the glamour, of 1930s Moderne.

50 Elgin Place Congregational Church
193–95 Pitt Street/240 Bath Street
1855–56
Architect: John Burnet

The great Ionic portico facing east suggests the influence of the Erechtheion at Athens but here there is no caryatid porch on the north. Raising the ground floor of the temple church above street level heightens the classical presence, as does Burnet's immaculate detailing of columns, tympanum, doors and windows. Internally, the same sophisticated restraint produced an auditorium which, with its central dome, white gallery and crimson pulpit platform, was described at the opening as 'quite beautiful – a perfect picture'.

Now much altered, the interior houses more secular activities in less sober taste – bar, restaurant, disco and night club. Fortunately, the building's exterior remains unimpaired, its scholarly street-corner gravitas preserved.

51 Mitchell House
Bath Street
1985–86
Architects: Thorburn Twigg Brown and Partners

One of few new buildings to recapture something of the unpretentious but careful brick warehouse vernacular of the last century. A glance at its neighbours on the mauled motorway margins to the west proves its abstemious skill.

The composition is simple: heightened ground floor, four storeys of piano nobile, and an attic. Brick cornicing, recessing brick planes that suggest pilasters and a round-arched end to the tall slots of office glazing, recall both Glasgow classicism and Chicago high-rise. In a location where no immediate grounds for contextual deference exist beyond perhaps a red brick response to the sandstone of the nearby King's Theatre, this is still a respectful urban building.

52 Charing Cross Mansions
2–30 St George's Road, Charing Cross
1889–91
Architects: J.J. Burnet of Burnet, Son and Campbell

Curving from Sauchiehall Street into Renfrew Street, the principal mass of this five-storey red sandstone tenement – rippling with decorative dormers, balustraded balcony and corbelled bays, but a tenement still – is a symmetrical convex quadrant of inventively French historicism, a consequence no doubt of J.J. Burnet's spell at the Ecole des Beaux Arts in Paris. Accented vertically by steeply roofed terminal pavilions and a still taller galleried cupola at the centre, the complex composition is masterfully bound around the corner by a third floor belt of balconied elliptical arches. Sculpture enriches the facade, particularly in a figurative swathe garlanding the central clock. Below, at street level, the restoration of the original shopfronts has been slow.

But it is a brutalizing townscape, inflicted on Charing Cross by redundant concrete aggression associated with the city's nearby Ring Road, which has done most harm. Yet despite the

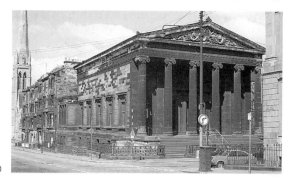

50

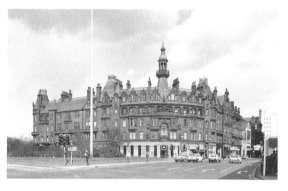

52

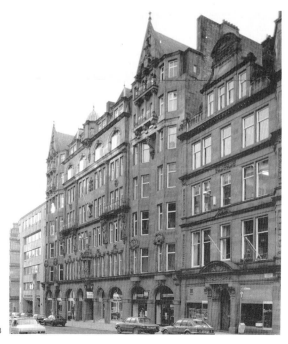

53

compromising clutter across the Cross, Burnet's unparalleled tenemental vigour has successfully made the transformation from street architecture to inner city bastion.

Blythswood New Town

53 **Daily Record Building**
Renfield Lane/St Vincent Lane
1900–01
Architect: Charles Rennie Mackintosh
restoration by Miller Partnership (1984–85)

While the plan of this, the second of Mackintosh's newspaper office buildings, is no more than an expanse of floor space stretched between two narrow lanes, the elevations are remarkable. Easy to pass by despite a downtown location and difficult to view in the narrow neck-craning confines of two parallel service streets, these glazed brick walls are wholly unexpected.

Sandstone is used along the segmentally arched openings of the ground floor and in the dressings at eaves and dormers but over the four intervening storeys white glazed brick is preferred, an increasingly popular choice for many of the dark and dirty backs of Edwardian high-rise. The facade to Renfield Lane is modelled in a tall shallow bay over what was the office entrance and at fourth floor level in a barely projected triple bay motif drawn perhaps from the Scots precedent of Huntly Castle. But it is the vertical series of coloured bricks stepping up the facade in naïve tree pattern that come as a surprise – intimations perhaps of later Art Deco abstraction.

54 **Mercantile Chambers**
35–69 Bothwell Street
1897–98
Architect: James Salmon II

All sense of orthodox classical syntax is abandoned. The very parts of speech – columns, cornices, etc. – are barely recognizable, enunciated in a new attenuated accent, squeezed and pressed by Glasgow Style diction into a language of form which Salmon would develop further in The Hatrack (q.v.). There too, the influence of the sculptor Francis Derwent Wood may well have been crucial.

Despite its seven storeys of sandstone symmetry, faint compositional echoes of the Arts and Crafts villa hover over the facade. Double-banked bays undulate below the gabled ends of the street front. But it is in Bothwell Lane that the full potentiality of the shallow bay is realized in a continuous curtain wall of lightweight faceted repetition. This, too, Salmon would take to more sophisticated heights in the north elevation of his later Lion Chambers (q.v.).

54

55 Offices

100 Bothwell Street
1980–87
Architects: The Holmes Partnership
with Newman Levinson and Partners

A massive ten-storey glass-sheathed box occupying the south-ern range of an entire city block of the Blythswood New Town grid but saved from the bland curse of corporate anonymity by a series of planar recessions in its reflective walls, shadow-gap detailing of the skin stressing a streetwise verticality, and a pro-jecting cluster of four individually expressed granite-clad lift tow-ers which soar skywards above the central entrance point, each to its own sliced-off prismatic rooflight. Ground and first floors sit back from the street behind the colonnade of the structural frame.

Elegant and metropolitan, the design does not lack distinc-tion. Yet it is this very polish – perhaps too self-consciously applied in the sleek steeple sculpture of the lifts – which some-how produces a building perhaps a little too abstractly detached from the architectural texture of the street.

56 St Vincent Street Church

265 St Vincent Street/Pitt Street
1857–59
Architect: Alexander Thomson

Temple and tower stand fast together on the southern side of Blythswood Hill. Beside its amazing spire, tumescent with 'exotic eclecticism', the church rises like the tiered pile of some Antique classical mausoleum. Set on a powerful plinth is an imploded mass of reverberating form: pylon answers pylon, pilastrade surmounts pilastrade, portico reflects portico. Over all a temple canopies the sacred inner space gripping it in the clutch of six Ionic pillars north and south.

In functional terms both these elevated porticos are without meaning, leading nowhere, the lofty church being sunk deep below within. Yet once within there is, paradoxically, no sense of hidden mystery for the inner architecture of the church is as spectacularly filled with space, light and warm colour as its exte-rior is dark and grimly palpable. Every detail intrigues.

57 Britoil

St Vincent Street/Bothwell Street/Pitt Street
1981–88
Architects: Hugh Martin and Partners

As the slip road for Glasgow centre swings off the motorway ring from Kingston Bridge, Britoil's massive headquarters building looms up on the left, a vast bastion at the edge of the inner city. Six storeys and more of glass and granite offices lying east–west along the city grid are punctuated by three taller transverse tow-ers containing services and circulation. Between these, internal courts step down in terraced gardens over top-lit atrium spaces. At each end of the building this stepped profile is exposed, the rising recession from Pitt Street a gesture of respect perhaps to Alexander Thomson's masterpiece, St Vincent Street Church, across the way.

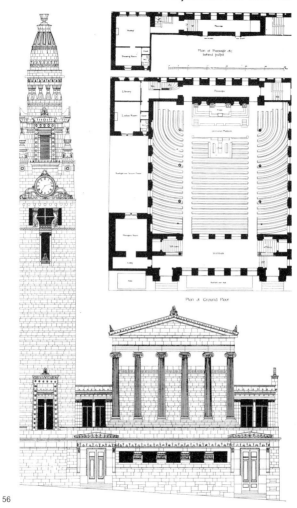

56

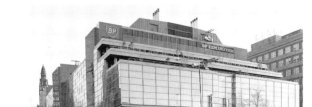

57

58 **St Jude's Church**
278–82 West George Street
1830–39
Architect: John Stephen

Built in the sloping western margins of the city's Blythswood New Town, at a time when the streets to the east were elegantly residential and land to the west was still open country, this small Episcopalian church was for much of the 19th century one of Glasgow's most fashionable places of worship. Its style was far removed, however, from the conventional formula of temple facade; instead, its hip-roofed preaching box was fronted by a tall aedicular porch on which stood a cylindrical belfry derived from the Choragic Monument of Lysicrates in Athens. Doors and windows were given battered architraves, the latter lugged, the former, i.e. the consoled main entrance door below the tower, decorated with paterae. The ornament is minimal but appropriately Grecian: a few akroteria and antefixae, some incised detail, an inscription in Greek script.

Converted to offices in 1975, the interior – save for some plasterwork above suspended ceilings – has been lost. The belfry tower has gone too. Yet this remains an important building in Glasgow's architectural history for Stephen was on that creative wing of the Greek Revival able to exploit forms and motifs in a way that led from the orthodoxy of the pedimented portico to the more inventive classicism of Alexander 'Greek' Thomson.

59 **Blythswood Square**
Blythswood Square
1823–29
Architect: John Brash

Such open spaces, greened or not, are rare in central Glasgow. Created as a hollow square in the hilltop grid of the city's Second New Town, its calming containment, inevitably weakened at the corners, relies on four all-but-identical walls of housing. The architecture is plain. Only the columned porches and a slight advance in the facade wall of end terraced houses in each range vary the planar continuity. Only the channelling of the ground storey relieves a textural blandness in the ashlar stone. Yet the square is dignified by its coherence, its uniform reserve intermittently enhanced by the gradual replacement of glazing bars. But there are exceptional incidents – Mackintosh's doorway inserted at no. 5 for The Lady Artists' Club, an original interior at no. 26 and, more problematical perhaps, the Frenchified remodelling of the east range carried out by James Miller in 1923.

60 **House**
196–98 West George Street
c.1830
Architect: John Brash (?)

While the houses of the upper streets of the Blythswood New Town submerged their individuality within the pavilioned hierarchies of street-to-street ranges as, for example, around Blythswood Square and along certain stretches of Bath Street, those on the lower slopes packed together in stepping terraces, aggregating a repetitive, still recognizable, single house unit. Here, half way up the hill, in the slightly wider plot of the corner feu, it was possible to design an urban mansion-house free from the usual elevational inflection necessitated by the narrow ter-

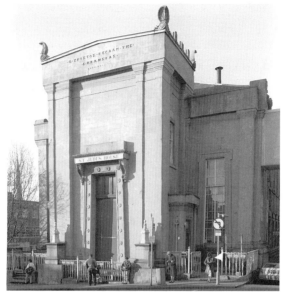

58

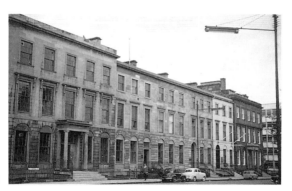

59

60

race house plan. Gable-to-gable with its eastern neighbour it none the less maintained an autonomous distinction derived from its five-bay facade symmetrically stressed by Ionic porch, pedimented first floor window and scroll-flanked chimney stack – unquestionably 'the finest individual house remaining on Blythswood Hill'.

61 **Wellington House**
120 West Regent Street/Wellington Street
1989–90
Architects: Cunningham Glass Murray

In a city so shaped by classical order in both its urban plan and its 19th century architecture, it is surprising there should be little or no infill evidence of ascetic Po-Mo rationalism. Wellington House does, however, present an elevational taxis that is remorselessly gridded, rather Rossi-like in its planar restraint, and remarkably successful. Lay the long Wellington Street facade on its face and you have the city plan; abstract its layered composition and you find that tripartite rule that governs Glasgow's classical street walls, residential or commercial – contextual, indeed!

The building fills an end block of the Second New Town changing from five to six storeys on the southern slope of Blythswood Hill. There is a gunmetal granite base above which rise three-and-a-half storeys of pink Donnington sandstone into which windows have been punched with the same clean-cut directness used by Burnet at 200 St Vincent Street two generations earlier. Above a chamfered cornice (the one major flaw) is a set-back lead-covered attic of small closely spaced identical windows – shades (literally) of Thomson. To the north and south, narrow return elevations, each symmetrical, play a perverse but clever game varying the layered window bays from nine to four to three, a device which, coupled with a tall central grid-glazed slot rising to second floor, imparts suitable emphasis to the West Regent Street entrance.

62 **Offices**
200 St Vincent Street/West Campbell Street
1925–27
Architect: J.J. Burnet

In this, 'almost his last work of any kind', Burnet combines the surface austerity of Modernism with the lingering compositional security of classicism to produce a strongly planar, almost cubic, corner block. A tough toothy cornice, clamped firmly on to the massy seven-storeyed box, is held in perspective between broad flanking chimney stacks which return symmetrically from the St Vincent Street wall while a hefty string course above the second floor marks the last vestige of the dividing cornice characteristic of so many of the city's inter-war banks. An arcade of five two-storey arches (four on the West Campbell Street elevation), all modelled in a muted Mannerist idiom, heightens the visual interest at street level – the perfect foil to the stark flat facades above.

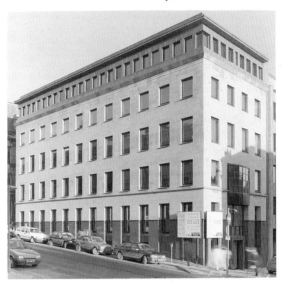

61

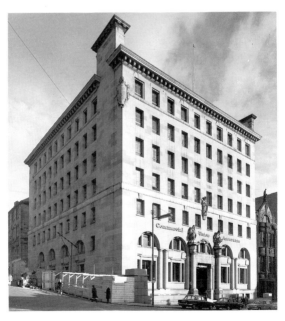

62

63 **Scottish Amicable Building**
150 St Vincent Street/Wellington Street
1972–76
Architects: King, Main and Ellison

A well-executed exercise in contextual modernism. The building makes no pusillanimous concessions to Glasgow's prevailing streetscape classicism – no cornices, no string course lines, no pediments – but does react brilliantly to the formal proportions and massing set by its neighbours. A strong verticality, established by tall square bays of tinted glass advancing and receding breaks down what might otherwise have been just another curtain wall office block. This articulated street wall works well on the corner with Wellington Street and in perspective, somehow respecting the scale of the second generation high-rise development of these once-residential narrow-fronted feus.

64 **The Hatrack**
142A–44 St Vincent Street
1899–1902
Architect: James Salmon II

Over its narrow elevational width, canted planes, more glass than stone, advance and recede in a play of light ten storeys high. The plan, which is exceptionally deep, follows a dumbbell profile, responsive again to the need for light.

This is perhaps the best building through which to grasp what is meant by the stylistic label 'Glasgow Style'. Here the elements of Glasgow's persistent tradition of classicism are transformed by the virulent fin de siècle infection of Art Nouveau. Columns are attenuated to stalk-like proportions, cornices squeezed out to the thinnest of ledges. To all this, sandstone submits almost like sculptor's clay. Yet, the columns are still columns, the cornices cornices and only in some of the subsidiary stone details, in bulging balconies on the eighth floor and in the ironwork of the lift hall, do the biomorphic forces of Art Nouveau fully prevail. In effect, a new anorexic concept of form destroys the building's mass stretching a transparent skin tightly across a skeletal frame of steel – a process which Salmon would take further in the north wall of Lion Chambers (q.v.).

65 **James Sellars' House**
144–46 West George Street
1877–80
Architect: James Sellars

In this design for the New Club, Sellars abandoned his earlier classicism. The compositional strategy for the elevation is a – b – a, the broad central portion of the facade, alternating three bays with five, rising through four storeys to a double attic: above a lower ground floor of three elliptical portholes is a range of five console-divided windows; above that a piano nobile of three tall pedimented and balconied windows; next comes a five-bay pilastrade and finally the high mansard roof tiered in three pedimented dormers and five lunettes. Forms reverberate up and down the facade – ovals at street level with those at the rooftop, pediments below with pediments above – but the scale is erratic, the super-imposition restless. In the flanks the vertical sequence is quieter and more orthodox, though the placing of the entrance portal to one side inevitably unbalances things. Sellars' name finds better commemoration in his Thomsonesque

63

64

idiom at St Andrew's Halls (1873–77) and Kelvinside Academy (1877–79) (q.v.).

66 **Lion Chambers**
172 Hope Street
1904–07
Architects: James Salmon II and John Gaff Gillespie

An early Glaswegian example of reinforced concrete construction using the French Hennebique System, Lion Chambers rose eight storeys on its tight corner site. Salmon spoke of an affinity between the new material and old Scots forms and, indeed, though there is no 'literal quotation', there are echoes here of the tower house – roll mouldings, corbelling, a corner tower, gabled and chimneyed roofscapes.

But with its generous office glazing this is in no sense a traditional building, and nowhere more so than on the north elevation where a rippling wall of wide shallow bays, reminiscent of earlier experiments Salmon had made at Mercantile Chambers (q.v.) on Bothwell Lane, demonstrates the new potential of frame construction. Even here, however, there are national allusions, for the three heightened bays of the topmost storey seem to recall a similar eaves feature at Huntly Castle and, by the same relationship, parallel the contemporary bayed treatment which Salmon's friend Charles Rennie Mackintosh was giving to the top floor 'loggia' at the School of Art.

67 **De Quincey House**
West Regent Street/Renfield Street
1888–90
Architect: Alfred Waterhouse

A five-storey-and-basement office corner built as Prudential Assurance Buildings by the company's architect, Alfred Waterhouse. Not quite in his usual 'Civic Gothic', the style combines ranges of transom-and-mullion windows with a roofscape at once Flemish Renaissance and Scots baronial in allusion. Walls are red brick with red sandstone dressings except in the internal well where white glazed brick and terracotta are used. Much more exotic, even Moorish, is the polychromatic Burmantofts faience on the walls and ceilings of the ground floor entrance areas now converted to a unique wine bar.

Both building and bar take their new name from the fact that the opium-eating English writer Thomas De Quincey (1785–1859) lived here, in an earlier residential building on the site, from 1841 to 1843.

68 **Offices**
84–94 St Vincent Street
1906–09
Architects: John A. Campbell and Alexander D. Hislop

An eight-storey steel-framed structure for the Northern Insurance Co. clad in front with Portland stone and behind, in St Mary's Court, with white glazed bricks. The street elevation, modelled by shallow planar recessions, is punctuated by three canted bays rising tower-like to the roof where they are separated by a deep consoled eaves. But it is the rear facade which is the more remarkable. Exploiting the same bay window theme to the full, the wall folds in and out across its entire eight bays. Steel permits large areas of glass, though the off-centre

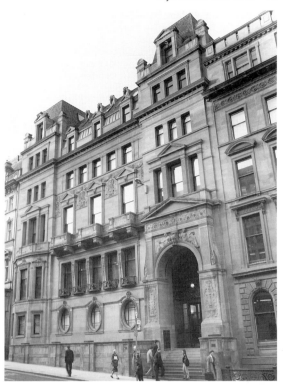

65

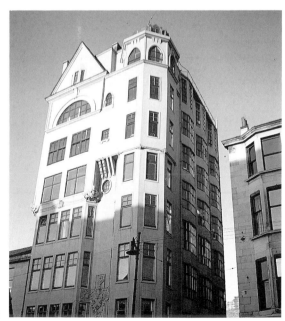

66

intrusion of the half-drop glazing of the staircase bay and changes in bay widths and window sizes add unexpected subtleties to what might otherwise have been a straightforwardly repetitive solution. It is this combination of a dominant frame-and-fill theme subject to contingent variation which has allowed the building to maintain a continuous fascination throughout the 20th century.

Central Station to Broomielaw

69 **Central Station**
Gordon Street/Union Street/Hope Street
1876–79; 1899–1906
Architects: Sir Robert Rowand Anderson,
Donald A. Matheson (engineer), James Miller

After the rejection of a proposal to cross the Clyde with a double-decked viaduct (1873), the Caledonian Railway Company finally succeeded in bridging the river (1876–78), thus extending their tracks from the south to reach a new city centre terminus off Gordon Street. Robert Rowand Anderson, the Company's architect, built several floors of office accommodation around the station concourse, but by 1884 he had been obliged to convert these into the 'Central Hotel', the result an eclectic composition variously derivative of Florentine, Dutch, Jacobean and even Swedish precedents dignified by a tall tower handsomely set with late Victorian city sense on the corner of Gordon Street and Hope Street.

As Glasgow prospered, travel on the railways boomed. Central was extended first in 1887 and again, just over a decade later, when the Clyde crossing was greatly widened (only the piers of the original bridge were left) and the 'Highlandman's Umbrella' over Argyle Street was classically curtained in filigree facades of cast-iron. At the same time the number of platforms was increased and the main concourse much enlarged.

Though the smartness of recent refurbishments to the concourse may have diminished the station's Edwardian charm (and grime), it is these turn-of-the-century changes made by Matheson with Miller's architectural help which create the vast airy spaces of engineered tracery that still take the breath away. Immense elliptical lattice trusses traverse the parallel platforms carrying a seemingly endless series of arched rooflights, ridged and valleyed from the built-up wall of Union Street on the east of the sunburst screens above Hope Street on the west. There is no better way to arrive in Glasgow than through Central Station and no more magical route to the city's heart than to plunge from this webbed cave of light out into the gridded streets.

Below, off Midland Street, is another world, an underworld of massive brick barrel vaults carrying the rumbling tracks overhead. Rescued from Piranesian gloom, it is now (1990) dramatically devoted to performance and exhibition.

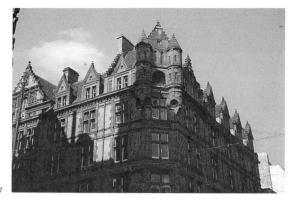

67

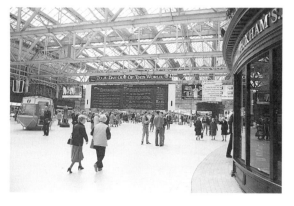

69

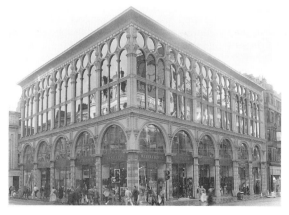

70

70 **Ca' d'Oro**
Union Street/Gordon Street
1872
Architect: John Honeyman
reconstruction by Scott, Brownrigg and Turner (1987–89)

Despite its name it is the lightness and laciness of its glass and iron facade rather than any very medieval configuration of tracery which justifies the evocation of Venice. Not a single pointed arch; instead, a three-over-one arrangement of rounded arches more like the syntax of Chicago Romanesque than sea-city Gothic. This is still a merchant's palace but a celebration not of white Istrian stone and variegated marble inlay but of the new structural and decorative potential of iron, the very material from which Glasgow's 19th century wealth had been forged.

Burnt out in 1987, the building has been splendidly restored. The removal of the peculiar mansard with Palladian-motif dormers, which J. Gaff Gillespie added in 1926–27, and the extension of the building by two bays down Union Street have only enhanced Honeyman's genius.

71 **Egyptian Halls**
84–100 Union Street
1871–73
Architect: Alexander Thomson

Thomson's greatest city warehouse: a magnificently modelled urban cliff of superimposed orders; eighteen replicated bays in which the visual weight of the columnar stack seems inverted. Above thin scroll-lugged posts at first floor are coupled pilasters and above these a hefty screen of Egyptian lotus flower columns marches beneath a massive entablature. In the shadows, behind this high-level peristyle, runs a continuous glazed wall – structure and skin precociously detached.

Recent years have seen the recovery of Thomson's anthemion band framing around each of the four street-level shops. But the six cast-iron lamps on dwarf Doric plinths which originally stood along the pavement kerb have not been brought back. Above, the building is empty, the facade shamefully neglected, its exquisite ornamentation more and more blurred by decay.

72 **Gardner's Building**
36 Jamaica Street/Midland Street
1855–63
Architect: John Baird I

One of the first buildings in the world in which both structure (patented by Robert McConnel & Co.) and cladding derived directly from cast and wrought iron. And yet there is somehow a Venetian flavour about this commercial architecture for this is still a corniced palazzo with repetitive arcuated facades. The difference is that there is an iron logic operating not only in the formal hierarchy of the facade subdivision but, literally, in the very material used to construct these delicate fully glazed walls. It is a brilliant paradox of the design that even in these thin gridded screens a cleverly calculated variation in the curve of each storey's arches subtly maintains the expected vertical diminution of classical architectural scale.

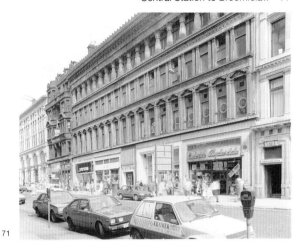

71

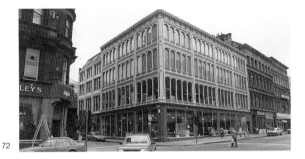

72

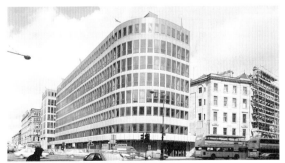

73

73 Westergate

Argyle Street/Hope Street
1985–87
Architects: Greenock and Will

Despite being anchored in Argyle Street some two hundred metres north of the Broomielaw Quay, this eight-storeyed facade sweeping round into Hope Street looks for all the world like the superstructure of a giant ocean-going liner docked in downtown splendour. Elegant and anonymously Modernist, it recalls the commercial chic of central European cities 50 years or more ago.

Inside, however, there is no such anachronism: deep office space allows for flexibility of layout, heating is subject to remarkably localized individual control, while a sophisticated lighting system responds to light cells and movement sensors. Services and security are constantly monitored by computer. Altogether an intelligent building but, for all its polish, just a little dull.

74 Pacific House

70 Wellington Street
1981–84
Architects: Comprehensive Design Group

Down Cadogan Street a prismatic sheath of mirror glass seems to slide in and out through a rhythmically grouped series of triangularly shaped brick piers. The broader bay window bays rising five storeys from first-floor level carry an echo – a reflection, too – from the elevation of J.J. Burnet's Atlantic Chambers (1899) which closes the street perspective to the east.

On the shorter entrance front to Wellington Street, the long:short rhythm of the structural grid continues, though here the facade steps down to the north from six to four storeys. This reduction creates several tiers of roof garden but since the stepping is developed through the line of the triangular piers, an oblique layering results which in distant perspective weakens the enclosing veil of the street wall. On the other hand, at ground level, the same 45 degree splay leads invitingly into the recessed shadowed entrance lobby.

75 Atlantic Quay

Broomielaw, Robertson Street/York Street
1988–90
Architects: Building Design Partnership

Atlantic Quay is the first phase of a vast extension of the city's commercial core from Argyle Street south to the riverside at Broomielaw. This initial development comprises three office buildings, varying in height from six to eight storeys, which fill the quayside city block from Robertson Street to York Street.

Much concern has been expressed about the impact which the total scheme will have on existing street lines running north from the river, on a number of magnificent but neglected listed warehouses in the area, and on the urban skyline so critically exposed across the Clyde to the southern approaches to the city centre. Some of this scepticism may yet prove justified but this first phase is certainly a townscape success.

Uncompromising in its silver anodized aluminium sheen and brise soleil glazed facades, it nevertheless responds in scale and form to the domed presence of J.J. Burnet's splendid century-old Clyde Port Authority Building on the corner of Robertson Street.

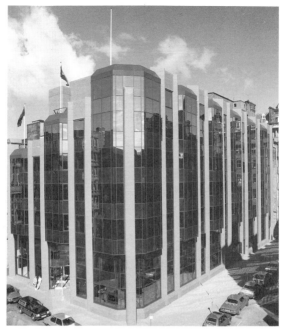

74

75

76 **Warehouses**
44–54 and 68–72 James Watt Street
1861–63; 1847–48
Architect: John Stephen

As so often in Glasgow, the mood is firmly, if severely, neo-classical: palatial formulae, already fully exploited for the terrace housing of the New Town, are now applied to the long light-seeking elevations of warehouses built within easy reach of the busy Broomielaw quays.

The facade of 44–54 is uniformly austere: layered in channelled base, double-height piano nobile and windowed entablature; the tripartite organization of its 13-bay length barely stressed at the centre but effectively defined by pedimented and pilastered end pavilions. At 68–72, Stephen, something of a transitional figure between orthodox Revivalism and the more creatively classical interpretations of Alexander Thomson, had already implanted the same pedimented tetrastyle portico motif at the centre of the elevation. Uniting this with his later warehouse commission, he was clearly concerned to maintain scale, detail and horizontal continuity along the street wall. Whether similar care will be exercised by current redevelopment remains to be seen.

77 **Housing**
Lancefield Quay, Broomielaw
1988–89
Architects: Thomson, McCrea and Sanders

It is all but impossible to discern that this long terrace of Clydeside housing is, in fact, a conversion. Only the colourful appearance of a deep steel beam below the second-floor level on the river facade betrays the structure of the old wharfside sheds. But even this disappears in the interlocking texture of sloping greenhouse bays, balconies and dormers which shine and shadow along this complex elevation.

Workshops, garaging and 92 houses of four different types have all been incorporated by using a clever five-storey section which recedes with height into the pitched roof. To Broomielaw, glazed staircase towers project from a more solid but still busy wall of variegated facing brick. Indeed, if this ingenious project has its weakness it is its rather fussy formalism and an over-liberal deployment of differing materials and colours.

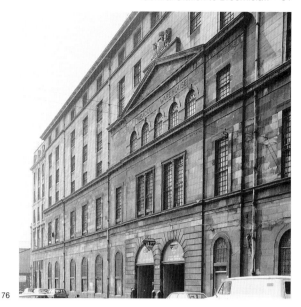

76

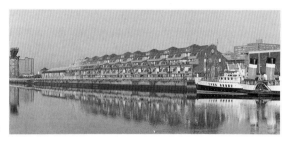

77

The West End

Charing Cross to Maryhill

78 **Mitchell Library**
North Street/Berkeley Street/Granville Street/Kent Road
1906–11, 1972–81, 1873–77
Architects: former St Andrew's Halls by James Sellars (1873–77),
W.B. Whitie, Sir Frank Mears and Partners
Glasgow's premier library, together with Strathclyde Regional
Archives, a small theatre and conference rooms, now fills the
entire city block from North Street west to Granville Street. On
the east is Whitie's original Mitchell Library building of 1906–11,
dramatically floodlit above the motorway ditch below, its domed
baroque palace form just a little cramped for space. On the west,
only the facade of what was once St Andrew's Halls (1873–77)
still stands. The loss of the auditorium, burned down in 1962,
has only now, a generation later, been overcome with the build-
ing of the city's new Concert Hall (q.v.) at the head of Buchanan
Street, but the retention of this majestic front is a reminder of for-
mer splendour. Something of the dignity, though not the spa-
cious setting, of Schinkel's Altes Museum in Berlin is evident;
part, no doubt of Sellars' second generation inheritance from the
vigorous Glasgow tradition of classicism begun by Stephen and
Thomson.

79 **Housing**
63–89 St George's Road/10–28 Woodlands Road
1900–01
Architects: Frank Burnet and Boston
By the end of the 19th century, tenement building had encoun-
tered and had mastered every conceivable urban location. Street
ranges were still under construction but less straightforward
sites were also being developed. However awkward the bound-
ary conditions, however difficult the problem of gaining ade-
quate light, a solution could always be found. Gushet
intersections were the most challenging, but whether the corner
was acute or, as here, obtuse, plan and elevation capitalized on
opportunity.

Everything focuses on the chamfered corner facing south to
Charing Cross. Above the shops, three floors of twinned canted
bays rise to an attic balcony and two vast semi-circular windows
above which springs a French roof with clock, dormers and ridge
ironwork. Three-storey chimneyed Chinese bartizans (the ebul-
lient eclecticism of the design seems to permit such description)

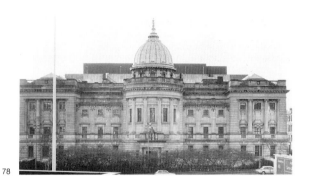

78

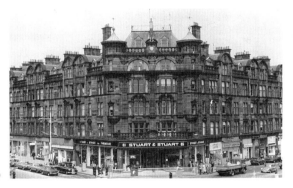

79

frame this facade while rhythmic red sandstone walls continue down St George's Road and Woodlands Road, a balustraded eaves picking up the line of the frontal balcony and broad round-pedimented dormers echoing the magnificent thermal windows of the central attic flats.

80 **Park**
Park Circus/Park Terrace/Park Quadrant
1855–63
Architect: Charles Wilson
The residential suburb of Park broke with the hitherto gridded street pattern of Glasgow's New Town expansion. Instead, con-toured terraces of houses, a few flatted*, were wrapped around a central hilltop circus. It was a layout which would reappear in the growth of the West End beyond the Kelvin.

Wilson's classical architecture, slightly attenuated but never tense, is coherent and stylishly contrived with subtle modula-tions varying the concave inner sweep of Park Circus and a bolder modelling of bays and Frenchified roofs on the outer curves of Park Terrace and Park Quadrant. Conscious of the wider urban landscape, he thus created a sandstone rampart ring behind which rose the towers of his own Trinity College (1856–61) and J.T. Rochead's Park Church (1856–57) – perhaps the most memorable piece of scenic architecture in all Glasgow.

At 22 Park Circus, James Boucher provided a lavish interior (1872–74) later further enriched in Art Nouveau Glasgow Style by James Salmon II and James Gaff Gillespie between 1897 and 1899.

81 **Trinity College**
31 Lynedoch Street/Lynedoch Place
1855–61
Architect: Charles Wilson
conversion by J. Cunning, Cunningham and Associates (1985–86)
Three tall square towers, their skyward thrust emphasized by the triple-arched slots on all twelve facades. To the west, the tallest of the three carries a balconied belvedere elevated on machico-lated corbelling. To the east, twinned towers rise like flanking sentinels on either side of a couple-columned temple front which originally marked the principal entrance to the College. Across the street the finialled Gothic of J.T. Rochead's Park Church (1858) adds a fourth and vitally complementary silhouette. Caught by the first or last rays of sunlight falling across the rooftops of Park Hill there is no more picturesquely lovely urban sight.

It was built as the Free Church College, a testimony to Dis-ruption faith – and wealth – but the spatial grandeur of its interior has been inevitably compromised by conversion. None the less, the building's adaptation to flats and offices has been sumptu-ously done.

* (i) divided into flats, i.e. separate storey levels or (ii) divided into separate apartment houses (flats) or (iii) both the above; thus used to describe the characteristically Scottish mode of urban living in tenements.

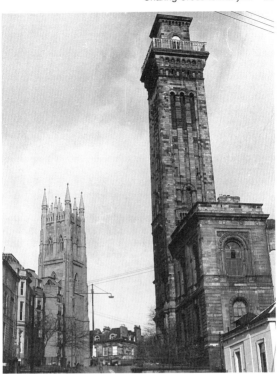

80

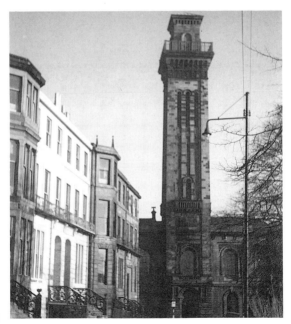

81

82 **Housing**
West Princes Street
c.1870–1900
Architect: unknown

The South Woodside area is one of Glasgow's most coherent stretches of tenemented townscape. On its earlier eastern edges, around Queen's Crescent (from 1837) and Queen's Terrace (1850–52), the scale is still New Town Georgian, the housing terraced and porched. But down the long line of West Princes Street, which, rather surprisingly, was developed from west to east, the four-storey flatted tenement, so ubiquitously characteristic of the city, comes into its own.

An underlying rhythmic theme of shallow bows, grouped windows and strong string courses unifies the perspective. There are variations too: a change in the colour of the sandstone available from c.1890 producing attractive polychromatic transitions, a growing Victorian fascination with the architectural possibilities of the corner resulting in conically capped bows at some of the later street junctions. Tall trees fill the broad side-street links to the bustle of Great Western Road, dulling the penetration of traffic noise and adding seasonal colour and texture to the civility of this residential retreat.

83 **St Mary's Episcopal Cathedral**
Great Western Road/Holyrood Crescent
1871–74; spire completed 1893
Architects: Sir George Gilbert Scott and John Oldrid Scott

Lacking the all-round urban presence of the same architect's eponymous contemporary church in the western New Town of Edinburgh, St Mary's still makes its steepled mark – over a hundred feet of it – in the long perspectives of Great Western Road. At closer quarters, however, the mechanically moulded quality of Scott's Early English detail proves disappointing.

The building, which houses 850, was erected to replace an earlier church in Renfield Street. Its design followed Scott's St Giles in Camberwell, London – a nave-and-aisles plan laid along an east–west axis with small chapels north and south and a deep choir and sanctuary in the east. Opening off the choir to the north is a small Lady Chapel while to the south, uneasily shoulder to shoulder with its transept neighbour, is the tall steeple. The tower is plain at the base, where four niches set in the angle buttresses contain statues of past bishops of the Glasgow see, but, immediately below the parapet from which the spire rises, its four wall faces have been heavily diapered.

In 1908 St Mary's was consecrated as a cathedral, a reward for episcopalian missionary zeal.

84 **Queen's Cross Church**
Springbank Street/Garscube Road
1897–99
Architect: Charles Rennie Mackintosh

Gothic, but red sandstone Art Nouveau Gothic, full of idiosyncratic detail inside and out. Church and hall are packed into an awkward site; a short turreted tower, its rather swollen design derived from a drawing of Merriot Church, Somerset, made by Mackintosh on a sketching trip two years earlier, holds but does not quite command the corner. A steep slated roof rises behind the gabled and buttressed forework to Garscube Road; within,

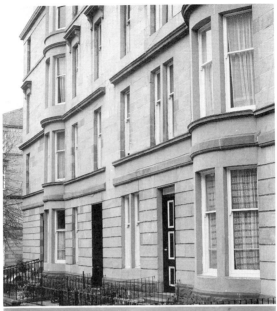

82

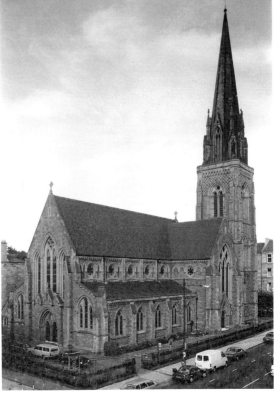

83

the nave has a barrel-vaulted timber-lined ceiling intermittently tied with exposed steel beams after the precedent of Norman Shaw's church at Latimer Road, Harrow (1887–90). Pulpit, chancel panelling and gallery fronts have unique carving; the hall shows Mackintosh's creative fascination with open timber trusses.

The Church is now in the care of the Charles Rennie Mackintosh Society which has restored it as a centre for the study of the architect's life and work.

Open to the public.

85 Housing (Queen's Cross West)
Maryhill Road/Bonawe Street/Kirkland Street
1987–88
Architects: Glasgow District Council Department of Architecture

Part of the transformation of Maryhill Road from four-storey walls of tenemented stone to lower-scaled flatted and terraced ranges of red brick, this 31-unit housing development fills a triangular street block opposite Mackintosh's Queen's Cross Church (q.v.). Accommodation is mixed, comprising family houses, standard and amenity flats; off-street parking is provided on the west and south.

On Maryhill Road entrances are defined by four boldly modelled brick drums, the central two of which flank an indentation in the street wall intended to help re-establish the spatial definition of the Cross. Corbelled bay windows recall the tenements but the three-storey scale, wide eaves and open-timbered gables, and, of course, the close-grained texture of the brick produce an architecture less than austere in its urban impact and thus perhaps more English in character than Scots. None the less, the brick detailing is carefully controlled while the reversal of the red/buff polychromy of the street helps give the inner courtyard space its distinct and private quality.

86 Craigen Court
Shakespeare Street, Maryhill
1987–89
Architects: McGurn, Logan, Duncan and Opfer with Ken MacRae

The tenement – four storeys of flats entered from a common stair – is quintessentially Glasgow. Despite the depredations of comprehensive redevelopment, street upon sandstone street remains to testify to the city's unique architectural coherence and scale. But survivors make demands which cannot always be met: to extend or infill these streets, matching materials and ceiling heights, seems all but impossible.

No better solution has emerged than this convex competition-winning wall of housing. An ingenious section marries four tall storeys at the front – designed to pick up the string courses and eaves of the adjacent tenement (c.1900) – with six at the back. There are 56 flats served by seven access stairs. Each staircase is glazed in a step-tapered slot falling from twinned chimneys to projecting porches – these last curiously detailed accretions. If blockwork imparts a slightly insipid quality to the facade, scale, proportion and texture are still creatively and powerfully in tune with the tenement tradition.

84

85

From the Motorway to Kelvingrove

87 **Housing**
392–448 St Vincent Street
1983–86
Architects: James Cunning, Cunningham and Associates

No building type is more typical and none gives greater architectural coherence to the city's streets than the ubiquitous tenement. Four-storeyed flatted living crosses the social barriers: uptown, downtown; West End, East End; middle class, working class. Repeatedly, however, the moral imperatives of 20th century change have challenged the tenement's role. Yet the model persists. Most recently, the cleansing excesses of the 1960s destroyed much of Glasgow's inner suburb streetscape. Two decades on, the mistakes are acknowledged, the need for new tenement solutions recognized.

This long strongly cut orange brick range is among the best of contemporary responses. The scale may be low – compare its rather crushed storeys with the real thing, high ceilinged and erect, further west – but there is a real sense of street architecture rhythmically and powerfully modelled without degeneration into pastiche. Sad to relate, cruder means prevailing at the ends of the range and along Kent Road seem to indicate a loss of nerve and investment.

88 **Housing**
St Vincent Crescent/Minerva Street/Corunna Street
1849–58
Architect: Alexander Kirkland

This extensive speculative development, built over a decade or so, made Stobcross for a time one of the most desirable suburbs 'out west'. The bulging bend of Argyle Street into Minerva Street, hanselled with giant pilasters, and the symmetrical bow-cornered walls of Corunna Street were all part of it but it was the slow snaking curve of the Crescent, looking south across riparian greenery, which set the seal of urbane elegance on the project.

The facade is ruthlessly repetitive. Every window is architraved with some given pediments; every doorway is pilastered with a few groups porched; the eaves coil out in a seemingly endless balustraded cornice. This is the fundamentally classical discipline of the 1850s tenement – for these are not terrace houses but flats, some with their own street door entries but most entered off the shared stone stairways Glaswegians call 'closes'.

89 **Student Housing**
Kelvinhaugh Street
1987–89
Architects: Cooper Cromar Associates

A long four-storey street wall development articulated by gabled recessions and projections. Hints of pediments and dentilled eaves give a flavour of Glasgow's tenemented streets, the impression of muted Post-Modern classicism heightened by banded rustication at ground floor and a string course below the sills of third floor windows. Even the strong ochre and orange polychromy of the brickwork has its century-old sandstone precedents.

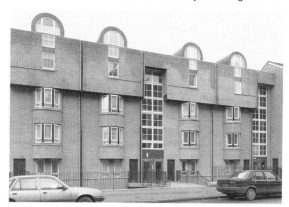

87

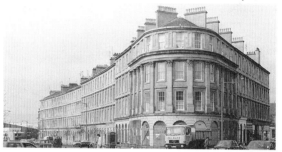

88

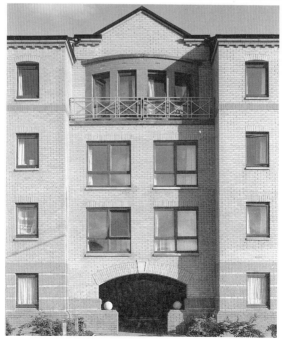

89

The first two stages of this project for the University of Glasgow have realized 72 student flats. Later phases are designed to add 114 private flats in a curved end to the street which will create a public piazza terminating the western end of St Vincent Crescent (q.v.).

90 **Housing**
1079 Sauchiehall Street/1330 Argyle Street
1990–
Architects: Cooper Cromar Associates

While Glasgow is rightly known as a grid-iron city, not every architectural problem is defined by the bounding ordinates of the rectangular matrix. Grids clash obliquely; old roads drive a 'circumstantial diagonal' across the pattern – the result is the gushet site – wide-angled or, more demanding, wedge-shaped.

Solving the latter problem, where two streets meet acutely, is not easy. One option, which Thomson used in his now-ruinous church at Caledonia Road (q.v.) and Sellars for his now-demolished one at the junction of Old Dumbarton Road and Argyle Street, is to treat one arm of the angle as dominant, marking the corner itself with some form of tower. It is this approach which is used here. Sensing the visual precedence of the Sauchiehall Street side, the architects have run a four-storey-and-attic deep-plan block of duplex flats along the north edge opposite Kelvingrove Park. On the south, the edge is opened up to allow sun into the wedge before the tenement wall of Argyle Street is continued. At the corner is a square-turreted tower enlivened above by the glazing and balconies of a superb penthouse but a little bleak below where two floors of offices lack the street-side life which a cafe or restaurant should have provided.

There are 36 flats in all, each with car parking space in the basement. Materials are oatmeal brick and tinted pre-cast dressings. The Post-Modern design takes cues from the muted classicism of the tenemented street but remains provocatively inventive.

91 **Glasgow Art Gallery and Museum**
Kelvingrove Park
1891–1901
Architects: John W. Simpson and E.J. Milner Allen

Built with the profits from Glasgow's great exhibition of 1888, it was ready for the city's international reprise in 1901. The design, won in competition, has had a bad press from purists. The plan, organized in majestic cross-axial symmetry – a galleried central hall entered through vestibules north and south leads east and west into galleried courts which terminate in corner pavilions – is the predictable Victorian solution. The style, distantly French Renaissance, is best categorized as inventively eclectic; no doubt it was this free historicism which endeared it to the assessor Alfred Waterhouse. The lofty interior overcomes its grey sandstone with something of the municipal lavishness of the City Chambers (q.v.), while the red sandstone exterior is still more architecturally rich, reaching a climax at the centre of the north front in a confection of copper-capped cupolas.

Seen from across the Kelvin, there is something almost church-like in the twin towers rising ahead of the steeply pitched roof of the central hall. This is fitting for Kelvingrove is a popular urban shrine honouring a concept of culture catholic enough to

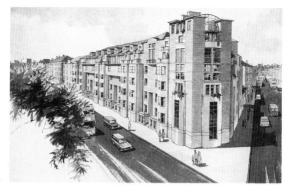

90

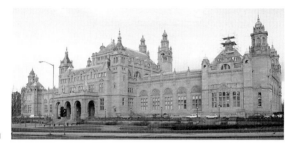

91

stretch from Dali and the French Impressionists to model ships and stuffed tigers.

92 Glasgow University
Gilmorehill
1864–70; 1887–91 (tower)
Architect: Sir George Gilbert Scott

Away from downtown squalor, the new university adopted a double court plan that was similar to, but more implacably symmetrical than, the layout of its medieval predecessor off High Street. Scott's Gothic could not, however, be described as collegiate: the scale is greater, the details harder, the style baronialized Flemish rather than Oxbridge Elizabethan. This is powerful High Victorian Gothic, machine-cut not crafted, iron and stone together.

Yet Scott successfully absorbed the 1690 Lion and Unicorn Stair from the Old College, placing it against his new West Range, and in the university gatehouse, Pearce Lodge (1885–88) – not by Scott – various other salvaged fragments were gathered in an eclectic bricolage.

The site on Gilmorehill is magnificent, the building's finest asset its spiky skyline, especially Oldrid Scott's tall central tower, latticed and turreted, which dominates the city for miles around.

93 Glasgow University Library
Hillhead Street
1968–72
Architect: William Whitfield

Louis Kahn's ideas of served and servant spaces may lie behind the disposition of the plan – eleven storeys of galleried reading spaces surrounded by lift, stair and service towers. On the skyline, however, uphill from the jagged silhouette of Scott's Gothic Revival University (q.v.), a more ancient pinnacled profile must have been in the architect's mind. The mix of precedents works. But at close quarters, particularly on the walls of the Hunterian Art Gallery which cluster around the base of the library towers, the craggy concrete of the 1960s, though well done, is scarcely user-friendly.

An inescapable, if quaint, enigma of the Gallery's Hillhead Street exterior is an inaccessibly elevated entrance doorway set in this Brutalist aspic. Behind, lies the jewel of the university's collection, the faithfully reconstituted flat occupied by Charles Rennie Mackintosh and his wife Margaret from 1906 until just before the First World War. It was recreated here after the original house in Florentine Terrace, Southpark Avenue, only a hundred yards east, was demolished in 1963.

Great Western Road, Hyndland and Dowanhill

94 Lansdowne Church
416–20 Great Western Road
1862–63
Architect: John Honeyman

Throughout Glasgow, like exclamatory punctuation in rigorously classical urban prose, Gothic verticals accent the long horizontal perspectives of the tenemented street. Nowhere is this more patent than down the relentlessly straight boulevard of Great

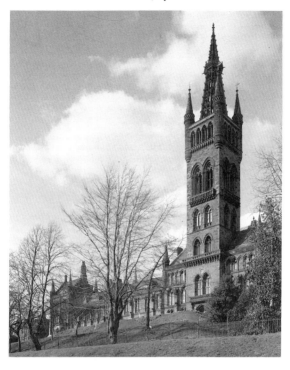

92

Western Road, and there nowhere more dramatically effective than in the slender shaft of Honeyman's first major church seen rising behind its lancetted and pinnacled western gable and above the gorge of the River Kelvin.

The church itself is orthodoxly cruciform in plan with gabled transepts and chancel apse, its interior distinguished by the method of access provided to the side pews of the four-bay nave, 'a corridor disguised as a low aisle on each side of the building'. Everything is Early English (Honeyman's scholarship was soundly based on extensive measured studies), save perhaps the amazing needle-sharp steeple, tucked into the angle between the south transept and chancel, which, more early French in idiom, soars to a height of 66.5 metres (218 ft).

95 **Kelvinside Academy**
Bellshaugh Road
1877–79
Architect: James Sellars

Rightly described as 'the finest school building in the city', this long corridor-plan building testifies to the persistent lure which the Greek Revival exercised on Glasgow architects. Sellars is manifestly in thrall to Thomson, and through him to the precedent of Thomas Hamilton's Royal High School in Edinburgh (1825).

On a projecting entrance podium a tetrastyle temple front dominates the composition, saddling the main two-storeyed body of the building which passes behind and below its four fluted Ionic columns. The piano nobile is a windowed pilastrade stretching seven bays on each side of the central parapet which transforms itself into a sill behind the central 'portico' where clerestorey glazing gives shaded western light into the school hall.

Like Thomson, Sellars has controlled the architectural landscape carefully. Not only is the school slightly but significantly elevated above street level, but pedimented stone portals rise from the ironwork railings marking the street boundary while, on either side of the school's principal entrance through the portico podium, two cast-iron lamp standards mount guard.

96 **Kibble Palace**
Botanic Gardens
1863–66
Architects: Boucher and Cousland?

A glass palace originally built downriver at Coulport but brought to Glasgow in 1871 and erected in the Botanic Gardens in 1873. There under Kibble's direction it became 'a stately pleasure dome' for the concerts and gatherings of West End society. Use as a place of entertainment proved in time incompatible with its function as a conservatory and in 1887 it was purchased by the City Corporation. A glazed approach aisle with a domed crossing and apsidal transepts were added to the original greenhouse, the presence of white statuary imposed a certain reverence for tropical horticulture and, though coffee could be had among the plants, a more tranquil, if humid, atmosphere prevailed.

Glass and iron are frequently measures of Glasgow's 19th century innovative architecture – Gardner's Building (q.v.), the Fruit and Fish Markets, the Ca' d'Oro (q.v.) and the Winter

95

96

Gardens at the People's Palace – but nowhere is their combination more spectacular or more exotic than in this miracle of translucency. Its glasshouse neighbours date from 1883.

Open to the public.

97 Grosvenor Terrace
Grosvenor Terrace, Great Western Road
1855
Architect: John T. Rochead

In none of Glasgow's West End terraces has the identity of the individual house been more completely submerged by the architectural expression of middle class solidarity. Five bays make a house but, because windows (and doors) are all similar, the proprietorial pattern of subdivision is wholly illegible; what results is a three-storey-high repetitive parade of glazed arches, like the facade screens of Venetian libraries on the Piazza S. Marco. Each windowed bay is conventionally defined by superimposed orders – Doric, Ionic, Corinthian; each entablature belt unorthodoxly enriched with consoles. Minimal advances in the plane of ten bays at each end of the terrace fail to dispel the potential for endless extension along the die-straight line of Great Western Road.

After a fire in 1978, much of the east end, by then functioning as a hotel, was rebuilt by T.M. Miller and Partners, successfully reconstructed not in the original stone but in glass-reinforced concrete.

98 Great Western Terrace
Great Western Road
1867–69
Architect: Alexander Thomson

As always, Thomson exploited precedent: raising the higher three-storeyed pavilions some distance in from each end of the terrace followed a model set by Charles Wilson at Kirklee Terrace a quarter of a century earlier. The classicism is now distilled to the purest spirit – remarkably so for Thomson – so that it is the elegant ashlar restraint of proportion and mass which alone makes a heady impact. Set back behind the trees, the architecture has an aristocratic calm yet its endless eaves, continuing across the raised pavilions in prominent sill-height string courses, seems to accelerate with the boulevard rush of Great Western Road.

Thomson's interiors, which vary house to house – no. 4 is best – provide the decorative ornament missing (save for the superb ironwork railings) from the exterior. In the higher pavilions a three-storeyed galleried stair hall rises to a glazed rooflight dropped into the building's core. At no. 8, Robert Lorimer added an interior for Sir William Burrell.

99 Housing
Queensborough Gardens/Airlie Street/Polwarth Street/
Lauderdale Gardens/Falkland Street etc.
1897–1910
Architects: John McKellar et al.

First conceived in a feuing proposal drawn up by City Architect John Carrick in 1875, the residential development of Hyndland only began in 1897 with a second but essentially similar plan produced for the estate owners by James Barr. By this

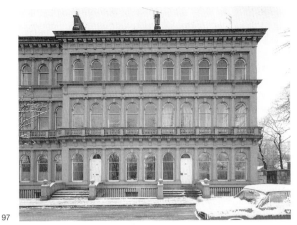

97

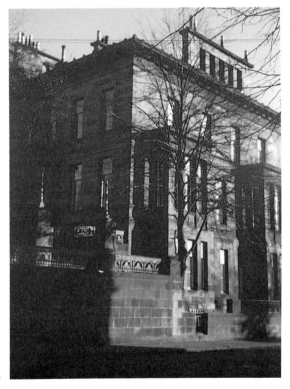

98

time electricity was available, trams and trains provided links to the city centre, and the development of adjacent estates was well underway. An upmarket tenement suburb soon took shape.

Red sandstone, a four-storey scale, rhythmic grouping of windows, the ubiquitous canted bay; all this maintains splendid urban unity. But diversity and inventiveness within the strictures of the theme are astonishing.

Bays are separate or twinned; down Hyndland Road, they change imperceptibly to bows. At the eaves, some bays run with the gutter, some are parapetted, some hip-roofed; some corners are square with chimneys; some octagonal, capped with bell-cast dunce's hats or swept up into clerestoreyed domes; many are paired across streets like glazed gateposts. Facades, like those in Falkland Street (1902) can be heavily crusted with ornament – rustication, string courses, consoles, aedicules – or, at the opposite extreme, in a rare post-World War II tenement infill in Dudley Drive (1948), puritanically plain. Street-flat doorways and close mouths are just as varied, from canopies and profiles in Queensborough Gardens (1902) to the simplified rectangular openings of Lauderdale Gardens (1906). Nor does detail disappoint, whether in carved stone panels, cast-iron street names, precise joinery or colourful stained glass. Hyndland has it all.

100 Belhaven – Westbourne Church
52 Westbourne Gardens
1880–81
Architect: John Honeyman

Suitably refined in detail for its select setting in one of the West End's most salubrious terraced squares this is perhaps the most architecturally elegant of Glasgow's many classical churches. Honeyman may have looked to St Paul's though the interpretation is delicately urbane rather than dramatically metropolitan; no dome rises behind but a two-tier pedimented portico of four pairs of close-coupled columns, Corinthian over Ionic, steps ahead of the shadowed church wall while two open-arched ogee-capped belfries flank the facade. Lower half-pedimented aisle walls project left and right but there is no suggestion of overlaid Palladian geometries. Instead, banded rustication stretches a uniform horizontal texture behind the paired columns and out to the left across the single-storeyed arcuated front of the church hall.

Inside, the church is wonderfully spacious although the atmosphere of its wide-span auditorium seems more attuned to the polite social reserve of the recital than the mysteries or corporate surge of worship. With a diminishing congregation the church may, indeed, yet find that its future will depend upon this peculiar suitability for music.

101 Crown Circus
Crown Circus
c.1858
Architect: James Thomson

As Glasgow grew into the workshop of the Victorian world, clean air and fine views drew residential speculation out beyond the Kelvin. The West End congeries of estates developed rapidly. Architectural quality assured its success.

Following a common pattern, Dowanhill Estate was built first on the high ground. Well named, Crown Circus is a wide

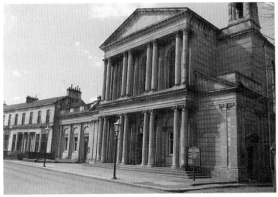

100

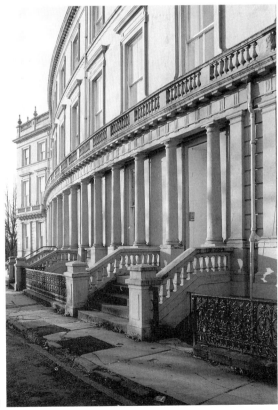

101

segmental curve of supremely elegant terraced housing. It looked back across the Kelvin Valley to the competition on Woodlands Hill, purer and more classically refined in its convex sweep than Wilson's contoured terraces at Park (q.v.).

Raised above street level, an austerely correct peristyle wraps itself around the graceful bow of the facade, only the pilastered centre and straightened wings exempt from its shadowed dignity. Above, however, a balustraded Roman Doric entablature unites everything in a noble coronet. The rest is abstemious; nothing de trop. There is a sense of lofty elevation and measured restraint. All in all, this is the aristocrat of Glasgow terraces.

102 Dowanhill Church

93 Hyndland Street/Hyndland Road
1865–66
Architect: William Leiper

Coming back to Glasgow from a London apprenticeship with J.L. Pearson, Leiper entered a brief partnership with Robert Melvin in 1864. Within a year he had won the competition for Dowanhill United Presbyterian Church with a design in characteristic Normandy Gothic idiom. A fine slender steeple, rising in four stages to the spire, cleverly accentuates the incline of Hyndland Street. Placed symmetrically behind is the nave articulated laterally by five traceried gables with buttresses between. To the west is a lower dormered hall, almost domestic in scale.

But the glory of Dowanhill was the astonishing richness within: stencilled paintwork and stained glass by Daniel Cottier, brilliantly and boldly polychromatic. No doubt it was the successful liaison of architect and designer which led to the church being exhibited at the 1867 International Exposition in Paris.

Since 1981 the building has been unused. Plans exist, however, to restore the fabric, recover the beauty of the interior and rehabilitate the church as an Arts Centre.

Further West

103 Moat House Hotel

Stobcross Quay
1987–89
Architects: Cobban and Lironi

High-life high-rise by the Clyde. Multi-storey living may be a thing of the past as far as Glasgow's housing is concerned but hotels are another thing. Out here in docklands there is at least some saving horizon drama to the formula. On a flat riverside site which has seen both docks and Garden Festival go, it all but succeeds in rescuing the neighbouring Scottish Exhibition and Conference Centre (SECC) – a brightly coloured but none the less ignominious shed – from an otherwise banal isolation.

The tower makes a bold skyline accent. Close to, it is a pleasantly modelled slab yet clad in a reflective curtain wall of silver-blue glass so uniformly applied as to conceal window and spandrel in scaleless reticulated abstraction. A two-storey podium containing restaurants and function suite stretches out along the river to the east perversely profiled in plan and section.

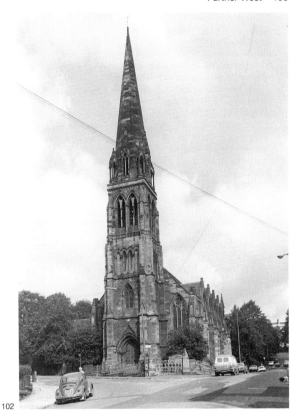

102

103

104 **Meadowside Granary**
Clydeside Expressway
extended 1936–37
Architect: William Alston (engineer)

Here is that same 'monumental power' which Gropius claimed 'can stand comparison with the constructions of ancient Egypt'. He wrote in 1913 and his silos were American, but a year later Glasgow, not for the first time a follower of transatlantic precedent, had built this dramatic riverside giant.

Twenty-six bays 12 ft long by 6 ft wide: the eastern twelve of these bays were devoted to a twelve-floor-high granary, the remaining fourteen to a silo granary of equivalent height. External walls of solid buttressed brickwork, reducing in thickness with height, provided an orthodox building shell around both the Considère ferro-concrete floors (supported internally by cast iron columns) and the gridded network of reinforced concrete silos. Grain entered from the quayside by two band-conveyors to the sixth floor, from which it descended by sack-shoots to be loaded for rail or road distribution, or it rose by inclined conveyors within the building to the twelfth level from which it dropped into storage.

Current design proposals to stack riverside flats rather than grain into these gridded concrete tubes could result in a unique high-rise conversion.

105 **Crathie Court**
Laurel Street/Aspley Street/Crathied Drive/Thornwood Avenue
1947–48
Architects: City of Glasgow Housing Department

Erected as a hostel for single women, this monumental building rises to eight storeys along the length of Laurel Street, an unexpected and uncompromising piece of Modernist drama on the red-tenemented hills of Partick. Articulated by portholed staircase towers at the centre and at the corners, where the building returns to enclose a sloping garden on the south, the accommodation comprises 88 flats, each with a living-room, bed alcove, kitchen and bathroom, and each entered off open balconies which stripe and shadow the architecture on the north, west and east with unrelenting horizontals. On the ground floor, in the south-west wing, is a large common room opening into a light-filled sun parlour – a gesture of environmental concern to match the social conscience of the residential accommodation provided above. Altogether a now historic sign of optimistic post-war times.

106 **Kelvin Court**
Great Western Road
1937–39
Architect: J.N. Fatkin

Two tall H-plan blocks of serviced flats (approximately 50 flats in each) situated along the south side of the city's main westward boulevard at Anniesland. A six-storey height prevails, except at one end of the eastern block where an extra level is made possible by the slope of the ground. Between the blocks is a low step-parapetted garage link.

The dark brick walls are strongly articulated by repeating columns of superimposed window bays – some canted some square – while bands of balconies, generally intermittent but

104

105

continuous at first floor and along the top-most storey, provide horizontal accent to the elevations. The entrances, which lie at the centre of each block and in the re-entrant angle corners, are cream painted and tiered up like small wedding cakes each supporting a hefty glazed brick candle marking the staircase shafts. At the rear, curved balconies give a 'more streamlined' look.

Flats have lift access with separate service stairs and kitchen lifts, all rather in the manner of earlier Parisian apartment buildings. The structure is a reinforced concrete frame.

107 St Benedict's Church*
Drumchapel Road, Drumchapel
1964–70
Architects: Gillespie, Kidd and Coia

Despite its rather unprepossessing setting, a brutalizing forecourt and the beleaguered tawdriness that time has inevitably brought to a grim, grey exterior of cheap roughcast and poor concrete, it is worth making the effort to breach this high sacred fortress. Once inside 'this quite amazing church' all the lofty spaciousness and brick poetry which won its designers national acclaim in the 1960s (more frequently associated with their almost contemporary work at St Bride's, East Kilbride) becomes clear.

The plan, which seems square but is in fact somewhat subtler in form with cut-off corners, responds to the liturgical changes of the time by placing the altar at the centre of the worshipping community. But it is the section which dramatizes the space. From the west, a steep triangle of beamed and boarded roof rises to a clerestorey running across the transverse diagonal of the church, while below this high ridge of light the other side of the roof bends down over its half of the square on curved laminated beams caught by the timber screen of the Lady Chapel in the east. The quarry-tiled floor steps down on east and west increasing the sense of shared containment at the heart. Pine roofs and brick walls glow with a raw religious warmth.

* During the compilation of this Guide, St Benedict's was unexpectedly and abruptly demolished (1991). To emphasize the degree of loss, it has been retained in the text.

106

107

The East and North

Around Glasgow Green

108 St Andrew's Parish Church

St Andrew's Square
1739–56
Architect: Allan Dreghorn
Mungo Naismith (master mason)

The first church to be built in Glasgow since the Reformation, this was also the 'earliest large-scale classical church in Scotland'. Its model was James Gibbs' St Martin-in-the-Fields, London (1722–26), though there were significant differences. Dreghorn's steeple is slender, does not taper and is stylistically much more provincial. If its relationship to the church below lacks satisfactory formal articulation, this is because the conception for St Andrew's is more totally that of the Roman temple than Gibbs' preaching box with its added pedimented portico. But the classical trappings are the same – pilastered sides, exaggerated quoining and window surrounds, Venetian window in the east – while in the vaulted interior everything is decidedly 'City Church'. Some bold flourishes of plasterwork by Thomas Clayton are unexpectedly rococo in manner.

In 1768 a local Act was passed aimed at achieving a formal street connection through to Saltmarket. But it was not until c.1785 that the surrounding residential square of quiet Georgian elegance appeared. Now that this has gone the great church survives uneasily in splendid if regrettable isolation.

109 Mansion House

52 Charlotte Street
c.1790
Architect: unknown

Laid out in the 1780s, Charlotte Street connected Gallowgate to Glasgow Green. In the context of the city's 18th century expansion it was unusual in its location being east of Glasgow Cross rather than west. Its architecture was, nevertheless, entirely consonant with the up-market mansion house style favoured by the city's merchant and professional classes – David Dale, co-founder of New Lanark, lived at the end of the street next to the Green.

The southern end of the street was developed with twelve houses, six on each side: though not identical all were two-storeyed, Palladian in organization, five bays wide with a pedimented three-bay centre. Single-storey pedimented links

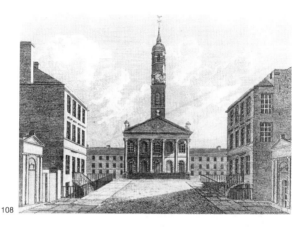

108

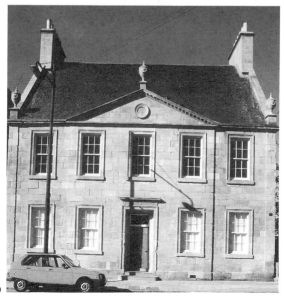

109

maintained a continuous street wall.

Fashionable until 1824 when London Street (later Road) was cut through from Glasgow Cross, and subsequently surrounded by the industry and squalor of the East End, the street was still largely intact in 1900. Today no.52 alone remains. After a long period as a hapless A-listed relic in dire straits, it has been restored by the National Trust for Scotland under its Little Homes Improvement Scheme.

110 **The People's Palace**
Glasgow Green
1893–98
Architect: A.B. McDonald (city engineer)
Built at the end of the last century as a cultural centre for the East End, the People's Palace retains its predominantly working class orientation as a museum of Glasgow's social history. Approached from the north it does indeed look like a museum: a squat red sandstone French Renaissance facade, pilastered piano nobile, domed centre – worthy but dull. But pitched on the Green, bursting out from the rear of this rather staid frontispiece, is a winter-garden marquee. Here is a park within a park: a white ribbed cathedral of glass – nave, aisles, apse and transepts – luxuriant with tropical vegetation and exotic hot-house plants.

Open to the public.

111 **St Andrew's Footbridge**
Glasgow Green/Adelphi Street
1854–55
Neil Robson (engineer)
Not the largest and not quite the oldest but unquestionably the prettiest of the Clyde bridges; it links Glasgow Green to the once-tenemented streets of Hutchesontown. The structure spans 67 metres in wrought-iron flat-link chains and suspender bars slung between riparian portals, the curve of the suspension chain echoed in the convex sweep of the elegant railings which edge the approach from the northern embankment.

Each cast-iron gateway to the bridge has four fluted Corinthian columns supporting a full entablature roofed with a shallow leaded pyramid. Above the capitals of the twinned columns on each side, suspension chains pass neatly through the frieze and down to their anchor points.

Despite daubed graffiti and neglected riverside landscape, the bridge keeps its charm. Little used, it seems now to transcend practical purpose: Victorian engineering as parkland folly.

112 **Templeton Business Centre**
Glasgow Green
1889
Architect: William Leiper, south wing by George Boswell (1935–36) restoration and conversion by Charles Robertson Partnership (1980–85)
A building to take the breath away. For his carpet manufacturing clients, Leiper unrolls a facade design of such formal and polychromatic inventiveness that its quality even excels its Venetian precedent. Perhaps it is the colour that astonishes most – reds, pinks, yellows, blues – but the traceried and diapered pattern is equally amazing, an exotic tapestry of stone, brick and mosaic hung above Glasgow Green, its fringes wrapped up in Rapunzel

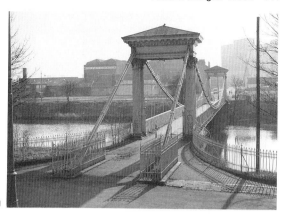

111

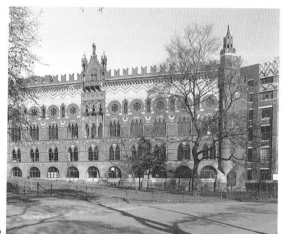

112

towers, the eaves tasselled in Saracenic cresting.

George Boswell's Art Deco wing to the south all but matches Leiper's achievement in daring 1930s style.

113 **Housing**
374–78 and 394 Gallowgate
1771
Architect: unknown
restoration of 374–78 by McGurn, Logan, Duncan and Opfer (1981–83)
restoration of 394 by Scottish Special Housing Association (1981–83)

Two rare, now restored, relics from the eastern edge of the 18th century town, separated c.1866 by Claythorn Street. Both follow the same robustly Scots model. Nos 374–78, somewhat less elevationally erect, relate directly to the street through a symmetrical pilastered pub front – 'Hielan Jessie's'. 394 is the grander of the two – skew-gabled and austere like its neighbour, its plain front is, however, doorless but, topped by a stepped-up chimneyed gable flanked by matching dormers and framed strongly in rust-coloured in-and-out chamfered quoins, decidedly dignified.

Central wallhead gables are repeated at the rear of both buildings. Alongside, circular turnpikes rise to neat conical roofs; that to the west sports a new weather vane cock.

114 **Factory**
Bain Street/Moncur Street/Gibson Street
1876–77
Architect: Matthew Forsyth

Despite being predominantly a stone city, Glasgow had many Victorian factories and warehouses erected in polychromatic brick. A few, banded and sometimes arched in red and cream, remain – among the more architecturally ambitious is this former clay pipe factory, a matching pair of mirrored elevations facing Bain Street, separated now by one of the drearier infill entrances to the city's famous Barras Market, but originally linked by a two-storey arcaded screen with central arched portal. Each building is a four-storey and attic cast-iron structure ranging tiers of windows, set in an ochre brick framework of piers, pilasters, arches and cornices, against a background wall of red. At the centre of each five-bay facade is a two-storey high, five-light bowed oriel corbelled out from the ground-floor storey. Screening the section of the pitched roof above the fourth storey cornice, the stepped profile of a small broken-pedimented Renaissance church facade (brick still) terminates the three central bays of the elevation below. The brick arcading of the southern building – much the better scrubbed of the two – continues down Moncur Street returning into Gibson Street, this latter structure dating from 1867.

Nearby, down London Road, new local authority housing perpetuates the polychromatic theme into Glasgow's reconstructed East End.

113

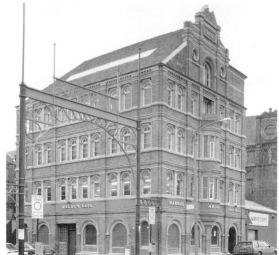

114

East Side/North Side

115 **The Forge**
Parkhead
1986–88
Architect: S.B.T. Keppie

Out of the devastated desert of Glasgow's East End the pyramids of Parkhead – 13 of them – rise above a flat 32 acre site to form a vast oasis of shopping and leisure. Besides large and small retail units, a food court, seven-screen cinema, petrol station and parking for 1750 cars are provided.

Malls and squares intersect, walls fold and splay, glazed space-framed pyramids peak to differing heights – the largest reaching 23.5 metres. The structure is steel, painted red; walls are in engineering brick, also red, or, where sloped, in sparkling stainless steel; the ubiquitous solar-control glass is tinted blue.

116 **Tollcross House**
591 Tollcross Road
1848–52
Architect: David Bryce
conversion by Nicholas Groves-Raines (1989)

By no means the grandest of Bryce's baronial country houses – but the only one in Glasgow. Built for the Dunlop family who, having prospered in the city's 18th century tobacco trade and banking, moved with the times into iron and coal. Following stylistic fashion, too, their Victorian home in Tollcross Park assumed the nationalistic allusions of mid-19th century revivalism. Though modestly two-storeyed and cast still in the less ebullient Jacobean mould introduced by Bryce's mentor William Burn, there is much here that is unequivocally Scots – crow-stepped gables, eaves dormers, a round tower with candlesnuffer roof, the square bartizans of Pinkie House and, not least, the freely asymmetrical functional plan.

Glasgow Corporation bought the estate in 1897 after which the Park with its ornamental trees, glen, century-old rockery, and domed conservatory were opened to the public. From 1905 until 1976 the mansion housed a Children's Museum. Now it has been converted to flats.

117 **St Anne's Church**
Whitevale Street, Dennistoun
1931–33
Architects: Gillespie, Kidd and Coia

First and finest of Jack Coia's pre-war churches in Glasgow, all of which in fresh, almost ascetic displays of space and surface seem still able to resonate with tradition. Here, pedimented gable and flanking scrolls are all that survive to recall the classic front of the Renaissance–Baroque church, for the west wall is boldly no more than wall – a vast richly textured expanse of rough red brick. No framework of column and cornice articulates the facade; only the recurring motif of the circle, from scrolls to wheel window to the round-arched triple-doored porch. Broad brick arches pick up the theme in rounded dormer gables over tall windows to the aisles and sanctuary, their semi-circular profile pushing through a mansard-section roof into the smooth piaster surfaces of a wide barrel-vaulted interior.

At 23 Whitevale Street this same arched gable marks the

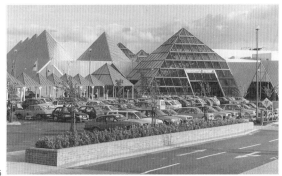

115

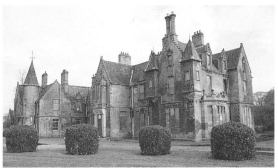

116

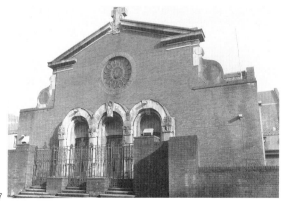

117

entrance to the adjoining two-storeyed presbytery, establishing, with the continued use of red brick, an affinity with the church. On the other hand, tall chimney stacks, wide eaves, a broad bay window and small-paned glazing all suggest a provenance more English that Italianate.

118 **Provan Hall**
Auchinlea Park, Auchinlea Road
c.1450
Architect: unknown

This small medieval manor survives today in a green island in the bleak council-house sea of the city's eastern approaches. It was probably built for one of Glasgow Cathedral's 32 canons at the same period as Provand's Lordship (q.v.) at the behest of Bishop Andrew Muirhead. Evidently the life of the canon of Provan entailed responsibilities more agricultural than devotional for Provan Hall is essentially a farm house equipped, though modestly, for defence.

The plan has a surprising regular elegance. Two parallel buildings of equal length are connected gable to gable by two parallel walls forming an enclosed court entered from the east through an arched portal. The 15th century northern block is two-storeyed with typically Scottish features: barrel-vaulted lower chambers, a conically capped corner tower (originally a stair), crow step gables, shot holes. On the south is what seems to be an 18th century laird's house though it has been suggested that this may be a conversion of a much older building.

Restoration was carried out between 1935 and 1938 by the National Trust for Scotland.

Open to the public.

119 **Springburn College of Engineering**
110 Flemington Street, Springburn
1908–09
Architect: James Miller

Built to house the administrative offices of the North British Locomotive Company, this large building adopts a standard courtyard block plan with an open inner quadrangle providing light. The still-classical main facade is equally conventional: three tall storeys rise to a cornice above which is a rhythmic attic pilastrade; massive book-end aedicules terminate the elevation echoing a broad three-bay projection at the centre.

But two things are exceptional. First, there is real quality in the facade sculpture, notably in the magnificent figures of 'Speed' and 'Science' above the main entrance and the steam locomotive which bursts through the broken pediment between them like an image from the surreal world of Magritte and, secondly, the yellow and white faience, striped with what now seems Post-modern boldness around the jambs and segmental arches of the windows of the inner court.

Sheer size is testimony to the once great part played by heavy industry in Glasgow's economy. It is fitting that, since 1962, the building has functioned as a college of engineering.

118

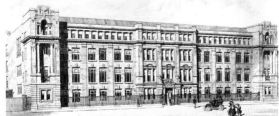

119

120 **Housing, Leisure Centre and Hotel**
North Spiers Wharf, Port Dundas
c.1851; 1869–70
Architect: unknown
restoration by Nicholas Groves-Raines (1988–89)
Along a hitherto derelict backwater of the Forth and Clyde Canal, eleven gable-to-gable mid-19th century warehouse blocks of differing widths and heights varying from five to seven storeys have been turned into a new top-of-the-town community. Less than a mile from the city centre 149 up-market flats, a sport and leisure centre, and several commercial units have been created. Most delightful of all, the former Canal House (c.1812), a detached two-storey mansion, pedimented and porched in modest Georgian style, has come to life again as a small hotel. Along the waterfront, cobbles, bollards and trees contribute to the renewal, while, from the quayside canoes, cruise boats and a floating restaurant will enjoy the Canal waters. In a city already famed for its creative recovery of the past, Spiers Wharf is an exceptional achievement combining architectural imagination and speculative nerve.

121 **Housing**
10 Raglan Street/434 St George's Road
1969–73
Architects: Boswell, Mitchell and Johnston
Two long eight-storey blocks connected by a short five-storey link with communal drying areas together constitute phase 3 of Woodside Development Area (A). There are 215 houses, 183 of which were intended for single, young married or elderly occupancy, the remainder being four-apartment family dwellings. All are reached directly off, or up or down from, access walkways threaded along the development at two levels and served by lifts and escape stairs at the ends of the block runs.

Such a description suggests the now-discredited 'streets-in-the-sky' concrete Brutalism of the 1960s, but this is not the case. In fact, there is a precocious but genuinely urban contextualism in these vigorous flats. The theme is the canted bay window of the Glasgow tenement; the oblique variations played here against the layered surfaces of two vertical planes in a facetted in-and-out counterpoint of light and shade, while the brick walls are red like the sandstone ashlar of the city's Edwardian streets. Like the tenements, too, these houses are built on load-bearing walls, some cavity brickwork filled with reinforced mortar.

It is much to be regretted that this early search for a genius loci in the city found no further refining exploration.

122 **St George in the Fields**
485 St George's Road
1885–86
Architects: Hugh and David Barclay
One of a family of churches in the city each of which has a hexastyle temple front facade raised up above street level. Here, unlike John Burnet's Elgin Palace Church (q.v.) the church itself is wider than the portico. The nave is taller too, so that a 'second pediment' roofline, crested with the necessary skyline accents of akroteria, rises above and behind the portico below.

The six columned facade has a long and honourable Glas-

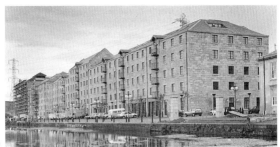

120

121

gow lineage going back through Thomson (1856 and 1859), Burnet (1856) and Clarke and Bell (1844) to Archibald Elliot's Royal Bank of 1827. As late as 1896, Alexander Skirving was still using the same model for his Langside Hill Church. The Barclays' version has the distinction of having the bottom quarter of its Ionic columns unfluted – a subtle restraint which seems to add to the gravitas of the portico – and is richly enhanced by William Birnie Rhind's finely carved tympanum sculpture.

A restoration scheme of 1972–73 only temporarily arrested decay. The church's recent conversion to housing by E.C. Riach has, however, ensured the retention of the shell of one of Glasgow's noblest classical buildings.

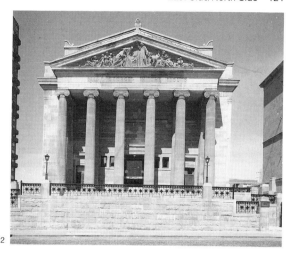

South of the River

123 **Glasgow Sheriff Court**
Gorbals Street
1980–86
Architects: Keppie Henderson and Partners
Wide open stepped approaches, sloping plinth and shadowed
peristyle must impress public and prisoner with the implacable
power of the law. The strategy of monumental classicism – deep
framing piers and long commanding parapet fascia – is familiar
in civic architecture: Boston City Hall and Berlin's Gallery of the
Twentieth Century come to mind, but here there are neither the
formal variations of the first nor the lightening transparency of
the second to relieve the unremitting weight of sandstone and
marble bearing down on forecourts and river alike. Evidently
designed to respect the skyline of Carlton Place (q.v.), the build-
ing nevertheless maintains a monumental detachment from its
surroundings.

124 **Carlton Place**
40–61 and 65–84 Carlton Place, Laurieston
1802–18
Architect: Peter Nicholson
Two of the city's earliest and longest Georgian terraces which,
despite the scars of later unwarranted incision, still provide a wall
of cool classical restraint along the south city-centre bank of the
Clyde. Each 40-bay terrace a three-storey palace with pedi-
mented centrepiece and porched end pavilions, these were the
plain but elegant residences of Glasgow's lawyers and doctors
escaping to suburban salubrity across the river.
 At 51–52 is Laurieston House, home of Nicholson's developer
clients, John and David Laurie. Behind its pilastered temple front
are two three-bay houses all but overcoming the gaffe of even-bay
composition by sharing the bold bow of a balustraded porch at the
centre. Inside are splendidly plastered interiors: echoes of Adam,
not least in the rooflit staircase rotundas.

125 **Warehouse**
Centre Street/Kingston Street/Commerce Street/Nelson Street
1981–82
Architects: Elder and Cannon
Consigned to down-market squalor by industrial exhaustion and
circumscribed by the isolating blight of railway viaducts and

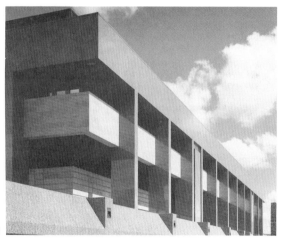

123

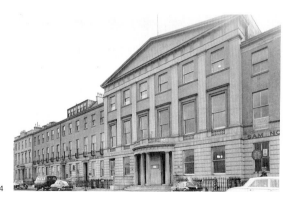

124

motorway feeder lanes, the cross-river districts of Tradeston and Kingston offer little more than the landscape of urban dereliction. On the ground, the regular grid-iron plan of what was once a desirable residential suburb survives but the streetscene is bleak.

But Post-Modernism to the rescue! Holding an entire city block of the original grid as if it were a threatened fortress, this wholesale warehouse walls itself off from its surroundings in brightly striped brick. Wide segmental archways penetrate the solidity of the walls with whimsically exaggerated monumentality while glass brick curves make perversely vulnerable corners. There may be a serious referential statement in the choice of ochre and orange brick – warehouses of a hundred years ago wore the same polychromy – but overall there is a jazzy flippancy, particularly in signs and lighting, more than welcome in this otherwise depressing part of town.

126 Caledonia Road Church
Caledonia Road/Cathcart Road/Hospital Street
1856–57
Architect: Alexander Thomson

Confronted with the challenge of a difficult gushet* site, Thomson produced a deceptively naïve plan for this his first church. Two symmetrical geometries are pinioned together in a memorably severe campanile: to the east, filling the width of the narrow Caledonia Road front with its raised Ionic portico, a galleried temple box for Presbyterian worship; to the west, the acute wedge of a congregational hall. Schinkel's influence is already evident – unifying banded ashlar, solid podium and clerestory pilastrades, glazing set directly to the masonry. There may be debts to Glasgow precedent, too, notably in the Ionic temple front already used by Clarke and Bell and Burnet. But the skill in compact plan and light-filled section is wholly Thomson's.

A year after designing the church, Thomson continued the classical streetscape north along Cathcart Road and Hospital Street in ranges of four-storey tenements. In 1968 and 1973, however, these were demolished. Today, only the church, itself gutted in 1965, remains as a picturesquely towered shell marooned by the urban vagaries of south-side renewal.

127 Scotland Street School
Scotland Street
1904–06
Architect: Charles Rennie Mackintosh

A symmetrical School Board school with a central corridor plan. All the drama comes from the two great staircases which burst out from the north front, conically capped twin-drummed echoes of Scottish castle towers transfused and transformed with light. Between lie classrooms and at ground floor a central drill hall (with dinky infants' porch) planned by Mackintosh with no physical barrier to its surrounding circulation. Beyond the stairs are the horizontal windows of half-landing cloakrooms – intimations, it seems, of 1920s glazing. The long plain plane of the rear elevation is relieved by some of the architect's finest stylized

*cf. gusset – a triangular wedge-shaped piece of land, often used to describe the acute-angle plan building or buildings erected on such a site.

125

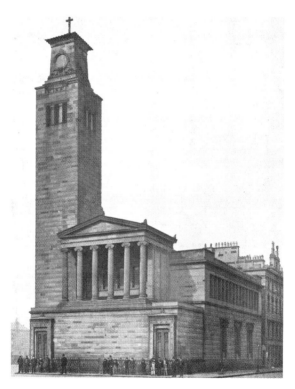

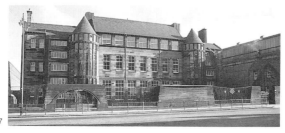

127

decoration, notably, in the middle, a suitably symbolic thistle motif.

Urban renewal, begun in the 1960s, removed street upon street of tenemental housing, destroying the school's catchment. Today, restored and cared for by Strathclyde Region, the building houses a Museum of Education.

Open to the public.

128 **The Toll Gate**
Paisley Road Toll/Govan Road
1986–88
Architects: Isobel Court and Graham Wylie

An ambitious project aimed at uniting living space and workplace in urban scale building. Since completion for the 1988 Garden Festival, however, the 38 flats, office accommodation and workshops have lain empty. Despite possibilities for varied tenure – 20 flats for sale, 18 for rent, and workshops available on lease – the intended integration of social and economic activity has, until now, stubbornly resisted realization.

The chosen urban form, a fan-shaped layout pushing a concave quadrant forecourt on the north side of the intersecting roads at Paisley Road Toll against the western wall of the 'Grand Ole Opry' music hall, is also problematic – unless some future circus-like development is envisaged at the Toll. On the other hand, the four-storey crescent of flats facing this public open space and its continuation along Govan Road establish the right architectural scale. But if the desired image is the Glasgow tenement, then the use of polychromatic brick, fussy flat iron window balustrades and close-patterned glazing bars recall the suburban estate rather than the dignity of the city street.

At the social and spatial heart of the design is an inner courtyard around which glazed galleries and arcades give access to offices below the flats and to the two storeys of office/studios and workshops which complete the eastern edge and curved outer spread of the fan plan. It is, potentially, a real community space.

129 **Housing**
Walmer Crescent
1857–62
Architect: Alexander Thomson

In a shallow curving crescent the three-storeyed repetitive residential wall is articulated by five seven-windowed two-storeyed bays pushing forward aggressively into the sunken area zone between tenement wall and pavement. The main facade has some more subtle planar changes and is full of Thomson trademarks: the running pilastrade – part solid, mostly void – at second floor; the stripe-jointed masonry; and, at first floor, that rhythmic architrave stepping above and between the windows, a feature frequently and characteristically Thomson's and one that may, it has been supposed, be a classical variant on a medieval hood-moulding theme. Here, because of the boldness of the formal play, there seems no need of anthemion, fret or palmette. At any rate, a sense of masculine vigour spurns the decorative.

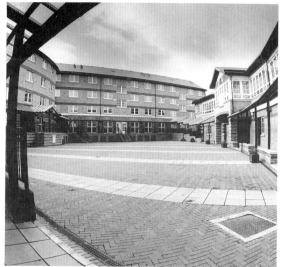

128

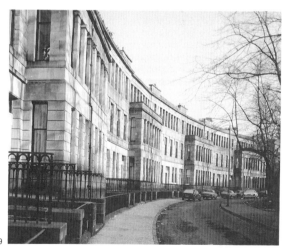

129

130 **Ibrox Stadium**
Edmiston Drive
1927–29; 1978–81
Architects: Archibald Leitch, T.M. Millar and Partners

Home of Glasgow Rangers Football Club: since 1929 the 28-bay-long pressed red brick facade – its colour and texture subtly varied by header course bonding and terracotta facings – has fronted a grandstand originally capable of accommodating almost 26,000 spectators. On either side of a grand thermal window centrepiece, ten tall round-arched window bays, marked out by giant order pilasters, stretch east and west above segmentally arched turnstile entrances to terminate in double-bay pavilions. Centre and ends advance slightly and rise above a continuous eaves cornice in blind attic panels, that at the centre carrying the name of the club, 'Rangers FC', in blue tiles on a white tile ground.

From 1978 three new stands, in which the use of red brick is maintained, were constructed on the north, west and east. These improvements, coupled with more recent changes to the 1929 main stand, which still retains its considerable architectural dignity, have placed Ibrox Stadium among the best appointed football grounds in Europe.

131 **Craigie Hall**
6 Rowan Road
1872
Architect: John Honeyman

Craigie Hall can serve as representative of those substantial late Victorian villas and mansions which sit secluded in the leafy plots of the inner suburbs of Dumbreck and West Pollokshields. It is not that the architectural style is typical – styles vary through Greek, Gothic and Baronial – it is more a matter of a characteristic confident presence, the built residential reflection of Glasgow's buoyant economy before the decline to come, that pride in conspicuous property that came before the fall of 20th century recession.

Here the idiom is Italianate with a splendid Ionic doorpiece to the north and a grandly columned bay overlooking the garden on the west. The interior is even richer, the columned marble-walled hall immediately impressive. But it is the woodwork and glass of the late Victorian and Edwardian alterations carried out by John Keppie and Charles Rennie Mackintosh which create something extra special, above all in the unique Art Nouveau organ case which Mackintosh designed for the Music Room.

The building is intermittently open to the public and can be viewed by arrangement.

132 **Palace of Art**
Paisley Road West, Bellahouston Park
1937–38
Architect: Launcelot H. Ross

One of only a handful of Glasgow's buildings from the 1930s – and the only on-site survivor of the city's 1938 Empire Exhibition. Lacking the formal innovation of several of the Exhibition buildings, still less addicted to the drama of Thomas Tait's memorable hilltop Tower, it possessed that disciplined austerity characteristic of so much inter-war Modernism. The plan, ruthlessly symmetrical, eight galleries arranged around a green inner court,

131

132

is decidedly, if naïvely, in the classical tradition, so much so that looking ahead to the court through the six blue-tiled pillars fronting the open but inset porch (later glazed in) 'reminds one', as a contemporary commentator put it, 'of the villas of Pompeii'. There is, however, nothing intimate or decorative: the architecture is severe, a stripped classicism relying on a pervasive gridded geometry not only in plan but in the patterns of glazing bars and risband-jointed* 'micra scraped' wall panels.

It was the only building intended to remain in its parkland setting after the Exhibition was over, but post-war needs necessitated change. In 1950–51 Ross adapted his original design for use as a community centre. Today it houses a variety of cultural and leisure activities.

133 **Art Lover's House**
Bellahouston Park
1901; 1989–90
Architect: Charles Rennie Mackintosh
realization by Andrew MacMillan

In 1901 Mackintosh entered the Haus eines Kunstfreundes international competition run by the Darmstadt publisher Alexander Koch. He did not win. But so exceptional was his design that he was awarded a special prize.

Ninety years later that design has been built in a Glasgow park. The site, which replicates the general conditions of the original hypothesized location, was occupied by Ibroxhill House (1801) until its demolition in 1914.

The Art Lover's House goes far beyond the Scottish inspiration of Mackintosh's other residential projects, raising the white box idiom to levels of formal abstraction not realized until the 1920s and 1930s. It is a large building and will be used not as the residence of some latter-day Maecenas but to provide high-quality office accommodation, its public rooms given over to intermittent cultural events.

In Pollokshields

134 **Housing**
1–10 Moray Place
1858–59
Architect: Alexander Thomson

Henry-Russell Hitchcock, the American architectural historian, called this 'the finest of all Grecian terraces' and one can see what he meant. It is not just the pedimented temple pavilions at each end nor the exquisite neo-Grec ornament which adduce the Antique to a modern context but the relentlessly repetitive masonry screen stretched stoa-like along the street. Varied here on the ground floor by the alternations of doors and windows and on the upper storey pilastrade by the interruption of blind panels marking the party walls that separate each five-bay drawing room from the next, such screens are a familiar feature of Thomson's oeuvre. But nowhere in his domestic work is the compositional strategy so charmingly deployed. Nor, despite his

* Risband is a term used to describe jointing in tiles or paving where the joints are continuous in both directions and thus form a grid matrix.

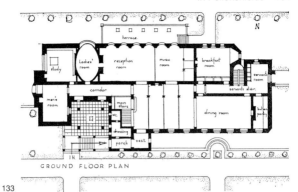

GROUND FLOOR PLAN

133

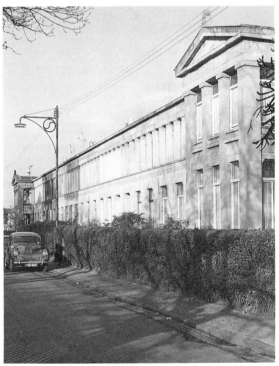

134

sobriquet, is Thomson elsewhere so consistently Greek – only the lotus flower chimneys are Egyptian.

135 Camphill-Queen's Park Church
Balvicar Drive/Balvicar Street
1873 (hall); 1875–83 (church)
Architect: William Leiper

Few if any towers pierce the city skyline south of the river with the slender beauty of this Normandy Gothic steeple, its vertical thrust brilliantly maintained through base, belfry and spire. Leiper's spell as a pupil of J.L. Pearson was, no doubt, the preparation for this achievement.

Detailing and carving to Balvicar Drive are superlative. Less convincing is the twin-gabled composition to the south-east and the rather cramped planning of the halls around a light well made even more unprepossessing by infill additions of the 1950s.

The interior of the nave is spacious and lofty with a darkly magnificent painted ceiling above open timber trusses, a decorative enrichment Leiper had also bestowed on his earlier Dowanhill Church (q.v.). In the chancel arch are three lancets with good stained glass – Fides, Caritas, Spes – by Daniel Cottier.

136 Pollokshields Burgh Hall
72 Glencairn Drive
1888–93
Architect: Henry E. Clifford

When in 1890 the young burgh of Pollokshields opened up 20 acres of 'tastefully laid out' greenery at Maxwell Park, it was reported that 'the chief ornament of its grounds' would be the new Hall then under construction. Building was not completed until 1893 by which time Pollokshields burgh had ceased to exist, annexed by Glasgow two years before.

Clifford's design, won in competition, provided two halls, seating 500 and 100 respectively, and a number of committee rooms, the whole held together in a tight rectangular plan. Economical as this arrrangement was its three-dimensional expression is lavishly modelled in the forms and detail of 17th century Scots style. To the left, the saddle-back-roofed main hall is clear. Behind a stout porch stands a tall tower-house. Linking the two is a complex elevation of tall windows, crow-stepped gable and projecting bay, the red-tiled roof of which wears the same conical hat as the tower-house turnpike to the right.

Set some distance apart, lodge and gate-piers complete a group unified both by style and by the consistent use of snecked red sandstone. There are, as yet, no signs of Clifford's later flirtation with 'Glasgow Style'.

137 Haggs Castle
100 St Andrew's Drive/Terregles Avenue, Pollokshields
1585–87; 1860; 1899
Architect: unknown
restoration by John Baird II (1860); alteration and extension by David MacGibbon and Thomas Ross (1899–1900)

More than the baronial revival mansion that might be expected in leafy Pollokshields – much more: this is, in fact, a 400-year-old tower house. It is true that the L-plan core of the building is an 1860 restoration of a ruinous fortalice abandoned by the

135

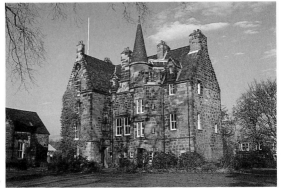

137

Maxwell family when they moved to Pollok House (q.v.) in the middle of the 18th century. True, too, that both the west front and the north wing date only from the end of last century. But the reconstructed fabric is still largely that of the ancient castle and the additions well matched in the scholarly revivalism of MacGibbon and Ross.

Crow-stepped gables, tall eaves dormers, triple-dentilled cornicing, slivers of ingle-neuk glazing in the angles of a corbelled chimney stack, above all, an abundance of cable moulding – Scottish details old and not so old have been fused in one delightful romantic conceit. In such a fairy-tale world it is peculiarly fitting to find a thriving museum.

Open to the public.

138 Pollokshaws Burgh Hall
Pollokshaws Road
1895–98
Architect: Sir Robert Rowand Anderson

Before its absorption into an expanding Glasgow, Pollokshaws had built its own Town Hall. Thanks to the generosity of Sir John Stirling Maxwell and the skills of his architect, who only a few years earlier had handsomely extended Sir John's nearby home at Pollok House (q.v.), it was a building of some distinction.

Two halls – one seating 1000, the other 200 – are set in parallel, the composition arranged in an aggregation of crow-stepped gabled roofs gathered below a square bell tower, the ridges of the former and the parapet of the latter topped off by condiment-like ventilators and cap-house. Anderson's design is Scots Renaissance in spirit for the walls are of snecked rubble, the decorative detail of windows and doors derived from those of the 17th century Glasgow College on High Street which had been demolished in the previous decade.

139 Pollok House
Pollok Park
c.1737–52; 1890–c.1908
Architects: William Adam (?); Sir Robert Rowand Anderson
and A.F. Balfour Paul

Classically severe, even for William Adam, this solid pavilion-roofed mansion is probably the fourth house built here by the Maxwell family since they acquired the estate at Pollok in the 13th century. Externally, architectural enrichment is confined to Gibbsian quoins and keystones, some swags and a central Palladian window on the south facade. A small kiosk-like cupola rises from the roof to light the main staircase. Inside, a more graceful elegance prevails. Some delightful plasterwork in the principal rooms may be the work of Thomas Clayton whose skills were employed on St Andrew's Church (q.v.).

Towards the end of the 19th century Anderson added the bow-fronted entrance hall which projects to the north and the two lower flanking pavilions, each of which cleverly picks up the Palladian motif and swags of the Adam house. He also laid out the terraces and gardens running down to the White Cart Water to the south which give the house its sense of dignified elevation.

At the time of these improvements, Sir John Stirling Maxwell installed his father's fine collection of Spanish paintings. Works by El Greco, Murillo and Goya can be seen at Pollok.

Open to the public.

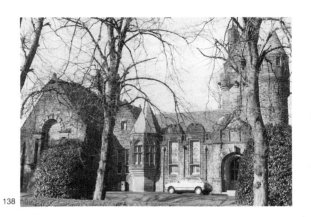

138

140 **Burrell Gallery**
Pollok Park
1972–83
Architect: Barry Gasson (competition won by Gasson, Meunier and Andreson)

Probably the most popular but in no sense populist piece of 20th century architecture in Scotland. People love to be here. They come to taste some fragment or flavour of Sir William Burrell's vastly catholic collection of art works and they come, too, simply to drink in the calm joy of the place. This is gentle architecture with no strident polemic, at once uncompromisingly ascetic and intimate.

The problem: to house Burrell's amazing treasure trove gifted to the City of Glasgow, an idiosyncratic horde of everything from delicate porcelain to massive Gothic portals. The solution: a shining stainless steel conservatory of art, the longest glazed side of its right-angled triangle plan pushed against the trees at the north-west corner of a picnic meadow so that there the peripheral circulation route becomes both gallery and woodland walk. Materials are few – red sandstone ashlar, polished concrete, laminated timber, plaster – and all detailed with exquisite reserve. And everywhere light: now, varied and graded across carpets, paintings and stained glass with technological precision; again, washing over walls and floors in a profligate lustral flood.

South Side Sweep

141 **Housing**
Ballater Street/Commercial Road/Wandell Street
1958–65
Architects: Robert Matthew, Johnson-Marshall and Partners

'Matthewtown', as The Architects' Journal referred to it in 1960, replaced part of the city's Gorbals–Hutchesontown area in the heady days of comprehensive redevelopment. Altogether over 400 dwellings were built, more than half in split-level flats cleverly stacked in four 18-storey blocks, the remainder in two-, three- and four-storey slab units. No longer buildings on a familiar street but concrete objects in an abstract landscape – a dramatic skyscape seen across the Clyde from Glasgow Green, but cold and placeless at close quarters. No longer the customary Glasgow grid but, in one vast superblock site, a new canted alignment for buildings, paths and paving swung in response to orientation rather than urban context. Optimism, social conscience and architectural assurance were never in doubt, but it was fortunate that the ethos of Corb's Ville Contemporaine encroached no deeper into Glasgow's inner city.

140

142 **Rutherglen Town Hall**
Main Street, Rutherglen
1861–62; 1876
Architects: Charles Wilson; Robert Dalglish and John Thomson

Amongst the earliest of Scottish town halls to espouse the Baronial Revival; fittingly, perhaps, since Rutherglen is one of the oldest royal burghs in the country – its status granted in the 12th century, five hundred years before Glasgow's. When built, it towered more than 100 feet above the single-storey cottages which then lined Main Street. Today, street scale has changed but the building is still commanding.

The high belfry is crowned with four crow-stepped gables separated by corner tourelles, the hall below dormered, bartizaned, and lit by a huge corbelled bay: how different it all is from Wilson's more familiar classical sobriety on Woodlands Hill. And yet how similar, for here, too, he draws the richest dividends from investment in townscape and skyline.

To the right of the tower, the 1876 extensions do not quite maintain the original Baronial boldness.

143 **King's Park Secondary School**
Fetlar Drive, King's Park
1956–63
Architects: Gillespie, Kidd and Coia

This is the larger of two Coia schools (the other is Our Lady and St Francis, Charlotte Street) in which a powerfully cantilevered reinforced concrete structure defines both the cross-sectional and elevational edge profile of classrooms, here ranged along each side of a central corridor spine. Below each of the upper-floor levels, a raking soffit creates a deep glazed recess over continuously windowed walls. Stretched out east–west and boldly modelled in this indented way, the four-storeyed teaching block is further dramatized by gaunt end stair towers. Poured concrete and blue engineering brick seal the Brutalist message.

Set parallel, closing the school yard on the north, is an administration wing containing kitchens, gymnasium, etc. Its single-storey, quite unexpectedly topped with a rather whimsical zig-zag roof, becomes three as the building cuts into the hillside to drop to the playing fields below. A third technical studies wing, two-storeyed and detached on the east at the upper playground level, completes the group.

144 **Aikenhead House**
King's Park, Carmunnock Road
1806; 1823
Architect: David Hamilton

Saved from the rotting brink of disaster, this suave mansion now accommodates several separate dwellings, a 1986 conversion anticipated as long ago as the early 1930s when it came into the possession of Glasgow Corporation.

It was probably Hamilton who, in 1806, built the central two-storey block with its plain front relieved only by an eaves balustrade raised above cornice level where a pediment might have been expected and pilaster quoins which contain the five bay elevation. It was certainly he who added the wings in 1823; single-storey links, slightly recessed from the principal west-facing facades, connecting to lower two-storey units pavilion-roofed like the main house but this time employing repetitive

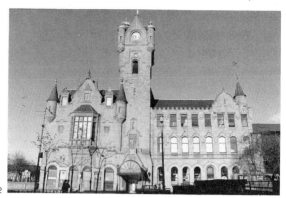

142

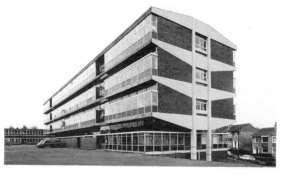

143

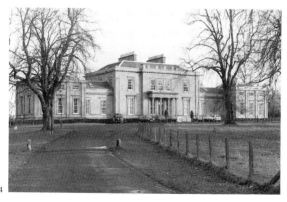

144

plain pilasters between bays. The composition is orthodox but skilfully abstemious, much enhanced by a pleasant salmon-streaked sandstone.

145 Double Villa
25 and 25A Mansionhouse Road, Langside
1856–57
Architect: Alexander Thomson

Two identical two-storey houses are built with a common gable and a mirrored, reversed, quarter-dropped plan. Thus, Janus-like, the building has no back. Seen from the west or east, the impression is one of a large detached villa rather than the humbler semi-detached reality. Moreover, in each view a unified asymmetrical composition is assured by having the blocky architectonic complexity of entrance porch, dining room bay and low-gabled first-floor dining room window placed to one side and ahead of the plain plane of the rest of an elevation which extends at each end in a single-storey service wing. Walls are in squared ashlar, there is some incised ornament around the porch, while Thomson's classical capitals appear in various forms on the pilaster mullions of the principal rooms.

Described as 'the only dwelling of its style and quality anywhere in the world', the Double Villa, like so much of Thomson's domestic work, seems to stand somewhere between Schinkel's earlier romantic Roman classicism and Frank Lloyd Wright's Prairie Style houses of 50 years later.

146 Holmwood
Netherlee Road, Cathcart
1857–58
Architect: Alexander Thomson

Full of invention, if not perhaps the most restfully composed of Thomson's houses. It is as if almost every element has won a new right to its own individual three-dimensional expression. As a result the massing is complex, though careful alignments in plan and section and the absorption of a long garden wall, coachman's lodge and entrance gates into the total scheme of things show the architect's extensive and extended efforts to co-ordinate and control.

The house, which faced north-east across a wooded valley to the ruins of Cathcart Castle, shows Thomson's signature throughout – low-pitched wide eaves gables left and right, a single-storey bow punching out from the parlour, pilaster or column mullions behind which glazed screens run freely, a cupola tower emerging from the cubic mass of a central staircase, and the linking precision of neo-Grec ornament, judiciously evident inside and out.

Strictly speaking, the house now lies outwith the city boundaries in Eastwood District.

147 Factory
Newlands Road, Cathcart
1911–12; 1928; 1949–51
Architect: Albert Kahn

Sometime before 1910, William Weir, managing director of the Glasgow engineering firm, Weirs of Cathcart, made a business trip to the United States. On a visit to Detroit, prompted perhaps by his personal obsession with racing cars, Weir bought a new

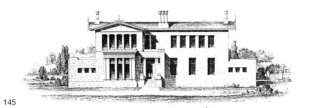

145

design for a factory then being built by the Packard company. The architect was Albert Kahn and the reinforced concrete construction system that of the Trussed Steel Concrete Company of Detroit run by Kahn's brother Julius.

By 1912 Weir had built his new four-storey factory in Cathcart, a starkly white regularly gridded wall of glazing, 150 ft by 50 ft. Apart from barely classical string courses and cornice, the building was a precocious expression of the new aesthetic of framed construction.

In 1928 James Miller added a fifth north-light-lit storey. After World War II, an east wing of eight new bays (1949–51) replicated the elevational appearance of Detroit's 'daylight factories' once more, though this time in steel frame construction.

148 Crookston Castle
Brockburn Road, Pollok
early 15th century
Architect: unknown

It is a strange sight to discover one of Glasgow's very few relics of medieval building in the midst of the vast Pollok housing scheme. Fortunately, the castle's hilltop site south of the Levern Water has been left space to breathe.

A slow climb from the south leads into trees, across a pronounced circumferential ditch and up into the towered ruin. The surrounding earthworks, which may date from the 12th century, are remarkably well preserved; the castle less so, but full of interesting detail. Alongside a still intact ribbed barrel-vaulted cellar, a straight-flight mural stair rises to the great hall above. The castle is roofless now, but the profile of its unusual egg-section vault can still be seen. To the north-east is a small but tall tower, the only one of four angle-towers to survive, the windows in its partly restored upper walls somewhat perversely skew-jambed on the outside!

The estate of Crookston took its name from the 12th century landowner Sir Robert Croc of Neilston though it was in Stewart hands from 1330. Since 1570 the castle has been abandoned.

Open to the public.

149 Moss Heights
Berryknowes Avenue/Mossview Quadrant, Halfway
1950–54
Architects: Glasgow Corporation Housing Department

Glasgow's first high-rise flats still look good on their suburban hilltop site. Three multi-storey slabs of similar ten-storey height but differing length stretch out west to east along the ridge above Berryknowes Avenue. The south front – decidedly a front for the north side has the grim face of second-best – is regularly shadowed by balconies which rise in tiers over the entrances in each of the slabs – two, six and three balconies wide, respectively – to lift motor rooms popping up above the long flat-roofed skyline.

Recent re-cladding (1987–88), replacing exposed aggregate concrete slabs with fibrous cement panels, has added a slightly post-modern zest: new cantilevered segments screening the rooftop clutter reflect the concave facings of the balconies below. Colour is predominantly ochre, as were the original elevations, but rust and blue patterning has been whimsically, though not aggressively, introduced.

148

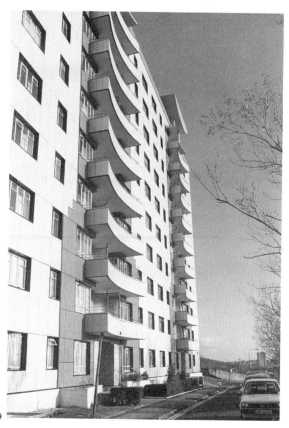

149

150 **Luma Light Bulb Factory**
Shieldhall Road, Shieldhall
1936–38
Architect: W. Cornelius Armour
Built by the Scottish Co-operative Wholesale Society, one of the
few organizations in pre-war Scotland willing to wed its image to
International Style Modernism, this electric lamp factory stands
in conspicuous desolation on Glasgow's western approaches
close to the motorway which links the city to its airport at
Abbotsinch. The building is a severe three-storey block raised
above the merely functional and utilitarian by a projecting bow-
fronted staircase which, above the flat roof of the factory box,
transforms itself first into an open ship's bridge balcony and then
into a tall fully-glazed conning tower show-case, once filled with
the flash and sparkle of countless electric bulbs. Now empty and
neglected, metal-section fenêtres en longueur rusting, stucco
spalling, it waits for Glasgow to switch on to the realization that
its 1930s buildings also need restoration.

151 **The Pearce Institute**
840 Govan Road, Govan
1902–06
Architect: Sir Robert Rowand Anderson
Endowed in memory of the shipping magnate Sir William Pearce
as an institution intended to cater 'for the religious, educational,
social and moral welfare of the inhabitants of Govan', The
Pearce Institute has always been at the centre of local commu-
nity life. It provides generous accommodation in a complex U-
plan grouping of buildings running back from its Govan Road
facade between Pearce Lane and the graveyard of the old parish
church.
 The 17th century Scottish idiom is recognizably Anderson's
varying here from the curvilinear gables and Renaissance detail
of the south and west to the less decorative but still Baronial
forms on the east and north. There is some fine carving, espe-
cially in the heraldic sculpture above the four tall windows which
light the main hall between deep buttresses. At the rear, a hip-
roofed bay, corbelled obliquely on a second floor corner, catches
the eye.

152 **Housing**
Elderpark Street/Fairfield Street/Fairfield Gardens/Fairfield Place
1984–86
Architects: Simister, Monaghan, McKinney, MacDonald
Two-storey red brick terrace housing set out in a strongly urban
layout of street and service court. Rudimentary brick pilasters
mark out the house widths while a brick-on-end sill course at
first floor defines a continuous black-tiled under-eaves 'frieze'
interrupted by windows and highlighted by tiled squares in white
and blue. Timber-framed grids appear, too, in doors and at tall
terrace corner glazing which stretches from ground-floor sill
level to the eaves.
 Some three-storey units push a red brick windowed gable
up through the black eaves frieze (now raised to second-floor
level). Below, open balconies recess over a massively columned
porch. These higher blocks introduce a robust touch of Post-
Modernism which, with the scheme's tight rectilinear layout and
its bold use of material, does much to overcome the suggestion

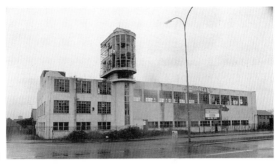

150

152

of suburban Arts & Crafts lingering in the wide eaves, gently pitched roof and fretted ridge tiles.

Carefully controlled in street plan, landscaping and architectural detail, this development is one of the city's finest of recent years. If it cannot match the old high-ceilinged four-storey scale of the bow-bayed tenement range surviving in nearby Elderpark Street, it could, nevertheless, provide a model for the future equally disciplined in urban configuration and continuity.

153 **Napier House**
638–48 Govan Road/Napier Drive, Govan
1897–99
Architect: William J. Anderson

Originally part of a tenemented townscape but isolated and bereft in the razed riverside landscape of today's Govan, Anderson's strange idiosyncratic architecture is now all the more evident. There are hints of Scots Renaissance in the dormers, signs of Tudor in the bay windows, an almost medieval robustness in the console bracketting of the Govan Road elevation. But oddest of all is the fenestration, particularly on Napier Drive, where, in a building which originally served as a model lodging house, it is difficult to understand the size and adjacency of openings.

Red sandstone – and the placing of chimneys and bays – merges the corner block into the street wall, despite extra height and formal complexity. In Napier Drive stone continues, but only at first; the rest is cast concrete, as are the floors. Reinforcement was scarcely designed: at any rate, while in construction the fifth floor collapsed killing five men. Anderson, already director of architecture at the Glasgow School of Art, died in 1900, his early death at 36 brought on, it was said, by remorse. Had he lived, he would have figured with Mackintosh, Salmon, Gillespie and others in the hagiography of the so-called 'Glasgow Style'.

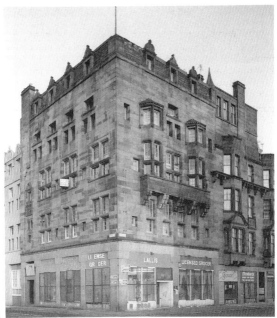

153

Illustration credits

The author is extremely grateful to the following for supplying illustrations: frontispiece RIAS/M. Anne Dick; 1 Frederick Selby; 2 M. Anne Dick; 3 RIAS; 4 Frank A. Walker; 6 M. Anne Dick; 7 Charles Brown; 8 Snoek-Westwood Photography; 9 The Royal Commission on the Ancient & Historical Monuments of Scotland (RCAHMS); 10 RIAS/Wylie Shanks; 11 Scotrail (BR); 12 Peter Clucas; 13 Page & Park; 14 Frederick Selby; 15 McGurn, Logan, Duncan & Opfer; 16 Frederick Selby; 17 Elder & Cannon; 18 Archive of Historical Architecture University of Strathclyde (AHAUS); 19 M. Anne Dick; 20 Charles McKean; 22 McGurn, Logan, Duncan & Opfer; 23 M. Anne Dick; 24 Charles McKean (top); The Architectural Press (bottom); 26 RIAS/Davis Duncan; 27 AHAUS; 28 M. Anne Dick; 29 AHAUS; 30 Alastair Hunter; 31 AHAUS; 32 M. Anne Dick; 33 Guthrie Photography; 34 RCAHMS /A. McKechnie; 35 RIAS/Charles McKean; 36 M. Anne Dick; 37 M. Anne Dick; 38 Charles Brown; 39 RCAHMS; 40 M. Anne Dick; 41 RIAB; 42 Charles Brown; 44 RCAHMS; 45 Hunterian Gallery, University of Glasgow; 46 RIAS/Charles McKean; 47 Frederick Selby; 48 Charles Brown; 49 M. Anne Dick; 50 James Burney; 52 M. Anne Dick; 53 RIAS; 54 RCAHMS; 56 L. Douglas Penman; 57, 58 M. Anne Dick; 59 Frederick Selby; 60 M. Anne Dick; 61 Cunningham Glass Murray; 62 RIAS/RCAHMS; 63 King Main and Ellison; 64 M. Anne Dick; 65 Charles Brown; 66, 67 Frederick Selby; 69 Scotrail (BR); 70 SBT Keppie; 71 M. Anne Dick; 72 Alan Sproull; 73 Greenock & Will/Graeme Duncan; 74 Comprehensive Design; 75 Building Design Partnership; 76 M. Anne Dick; 77 Guthrie Photography; 78 Charles Brown; 79 Peter Robinson; 80 Brian Edwards; 81 Frederick Selby; 82 Charles McKean; 83 M. Anne Dick; 84 Patrick Douglas; 85 City of Glasgow – Department of Architecture; 87 RCAHMS; 88 Charles McKean; 89, 90 Cooper Cromar/Guthrie Photography; 91 City of Glasgow – Department of Architecture; 92 M. Anne Dick; 95 Charles McKean; 96 Frederick Selby; 97 RCAHMS; 98 Frederick Selby; 100 AHAUS; 101 M. Anne Dick; 102 Glasgow District Council; 103 Cobban and Lironi; 104 RCAHMS; 105 City of Glasgow – Department of Architecture; 106 Charles McKean; 107 John Gerrard; 108 University of Strathclyde, A-V Services; 109 National Trust for Scotland; 111 RCAHMS; 112 M. Anne Dick; 113 McGurn, Logan, Duncan & Opfer; 114 M. Anne Dick; 115 SBT Keppie/Pat Shirreff-Thomas; 116 City of Glasgow – Department of Architecture; 117 Charles Brown; 118 City of Glasgow – Department of Architecture; 119 Mitchell Library; 120 Windex/ARC Photography; 121 G. Forrest Wilson; 122 E.C.

Index of architects, artists, sculptors and engineers

Index of buildings

Index of building types